G000310702

SITTINGBOURNE

THROUGH TIME

Robert Turcan

AMBERLEY PUBLISHING

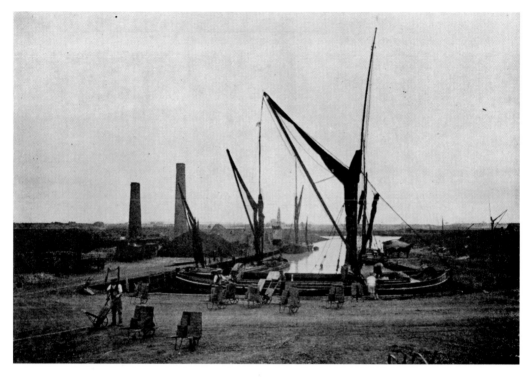

Loading bricks at Adelaide dock, Murston, 1920.

To Jocelyn and all whose present is enriched with a better understanding of the past.

First published 2009

Amberley Publishing Plc
Cirencester Road, Chalford,
Stroud, Gloucestershire, GL6 8PE

www.amberley-books.com

Copyright © Robert Turcan, 2009

The right of Robert Turcan to be identified as the
Author of this work has been asserted in
accordance with the Copyrights, Designs and
Patents Act 1988.

ISBN 978 1 84868 5208

All rights reserved. No part of this book may
be reprinted or reproduced or utilised in any
form or by any electronic, mechanical or other
means, now known or hereafter invented,
including photocopying and recording, or in any
information storage or retrieval system, without
the permission in writing from the Publishers.

British Library Cataloguing in Publication Data.
A catalogue record for this book is available from
the British Library.

Typeset in 9.5pt on 12pt Celeste.
Typesetting by Amberley Publishing.
Printed in the UK.

Introduction

Nostalgia is not what it used to be. In fact a passion for the past is becoming increasingly popular. The craze for photographic postcards a century ago has fortunately left modern historians with a fertile source of raw material. These images provide a window into life just before the dramatic impact of motoring.

My local town of Sittingbourne owes its very existence to its strategic position on a major transport link between London and the Continent. Watling Street was built by invading Roman legions. Over the course of two thousand years it has been traversed by many of the major characters from English history. The assassination and subsequent canonisation of Thomas Becket brought a stream of pilgrims into the town seeking temporary accommodation on their journey to his shrine at Canterbury Cathedral. Thus, even from early medieval times, Sittingbourne was known for its hostelries straddling what is now called the A2. By the eighteenth century stagecoach travel had reached its apogee and some of the most luxurious hotels in the kingdom where established at Sittingbourne. Its site, roughly midway between the capital and Dover, made it an idea overnight stop. The evolution of railway travel in the 1850s, however, stimulated greater growth when what was little more than an overgrown village began its transformation into a teeming industrial town.

The prosperity of the community was largely based upon the production of paper, bricks and cement. Agriculture also made a major economic contribution with rich fertile soils and a favourable climate assisting cultivation of food for London markets. Thames sailing barges were used to transport the bulky loads of bricks and cement which went to construct swathes of metropolitan expansion. They were the 'articulated lorries' of the time, plying their trade from wharfs and creeks just north of Sittingbourne. Rapid industrialisation brought a corresponding burst of domestic building. Streets of terraced houses

were erected during Victorian and Edwardian times to accommodate an army of artisans. Commercial wealth also spawned a spate of new churches and schools. One particularly paternalistic employer, Frank Lloyd (proprietor of a large paper mill), even provided financial assistance for the establishment of public baths, playing fields and a local hospital.

After the Second World War the decline in heavy industry and the electrification of the railway line presaged the latest phase of Sittingbourne's development. New extensive industrial estates sprang up where brickfields used to be. Most significantly, modern housing for London commuters sprawled inexorably across surrounding countryside.

Now Swale Borough Council's local authority planners are at last making a serious attempt to provide a better formula for the future. Hopefully, they will correct past mistakes with a fresh scheme which does not cut off the railway station from the town centre with a bizarre road system. Also they will attempt to recreate facilities for north to south pedestrian movement. More importantly they aim to regenerate what has sadly become a poor retail scene. Following these major proposals contemporary photographs from this book might eventually become a useful reference for future researchers. They could evaluate how, through time, the environment in which we live is perpetually altering, like the infinitely varied patterns of a kaleidoscope.

London Coaches

'Taking the Coach to London'. This is a phrase that has resonated in Sittingbourne for more than 200 years. Juxtaposed on this page are the old and new methods. Charles Dickens portrayed a coachman's work most graphically in the second chapter of *A Tale of Two Cities*. He described how the Dover Mail had ground to a halt just short of the top of Shooter's Hill and how this problem was dealt with. Kent coachmen were regarded as the finest in the country. Around 1820 they were of a rough appearance, but by around 1840 they had become dandies. Drivers of the fleets of commuter buses still exhibit a similar high standard of skill in their attempts to achieve punctuality.

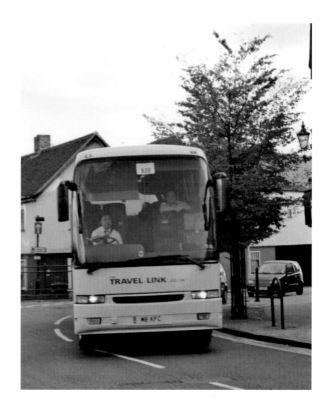

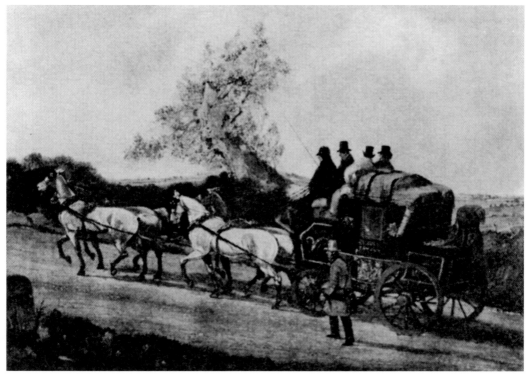

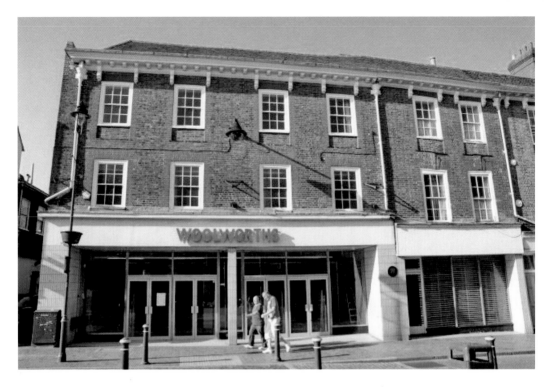

The Rose Inn

This hotel known variously as Jennings, Ballard's and the Rose is shown below in its full splendour. The pleasant, well-proportioned building retains its dignity above immediate street level. Who knows what its future is?

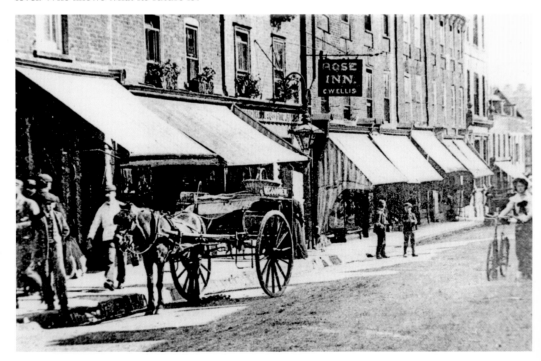

The Rose Inn Today

This inn was once known as one of the most luxurious hotels in the kingdom. It served the booming carriage trade between London and Dover. At the zenith of its fame the future Queen Victoria stayed here on her journeys to holiday in Ramsgate. Seen in the picture below is a rose badge plaque with the initials of a previous proprietor. The premises are presently vacant following the demise of Woolworths — a victim of the economic recession.

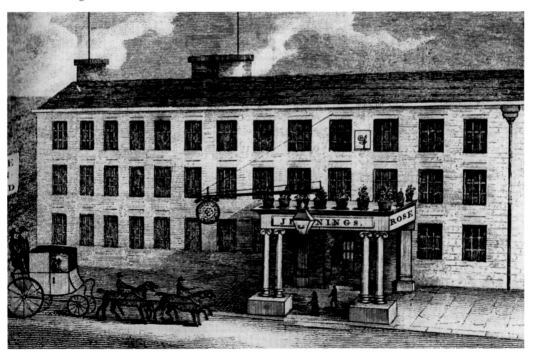

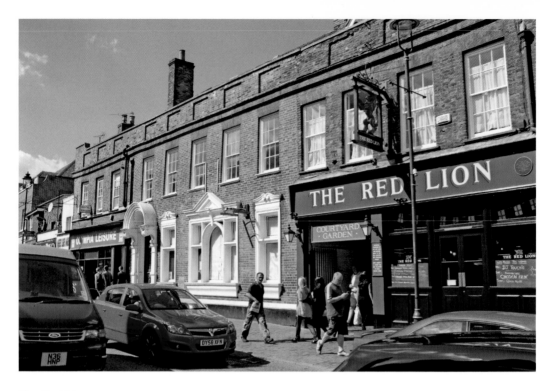

The Red Lion

The Red Lion has a rich historical background. As can be perceived below from the picture of the rear of the pub, it was once a much larger building. King Henry V was entertained here on his triumphant return from the battle of Agincourt. On this occasion the bill for wine consumed amounted to some nine shillings (45 pence). With wine at an old penny per pint, a bibulous evening was enjoyed by one and all.

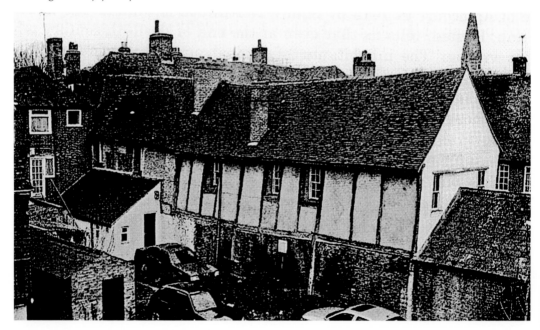

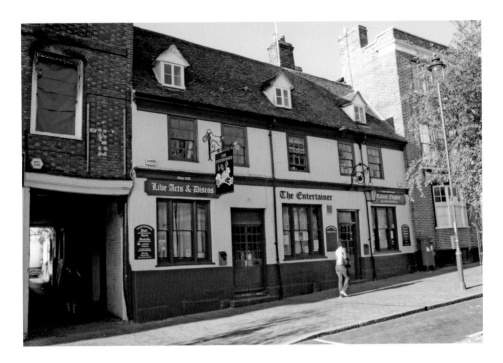

The George

The George (now The Entertainer) is another Sittingbourne public house with illustrious ancestry. It was once a coaching inn, and then an impressive town house owned by the Lushington family, who received the early Hanoverian kings as guests on their travels between their kingdoms. One person who successfully evoked the importance of this arterial route is the artist Vincent van Gogh. In his early adulthood he walked along this road on the summer morning of 17 June 1876 on his way from a short-term teaching post at a school in Ramsgate to the more socially magnetic London.

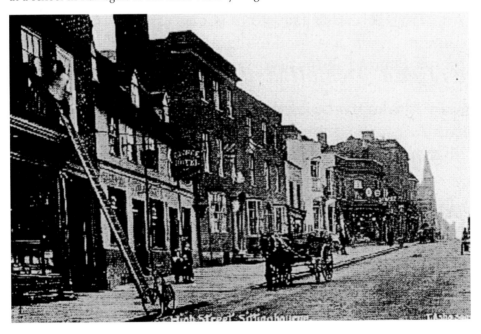

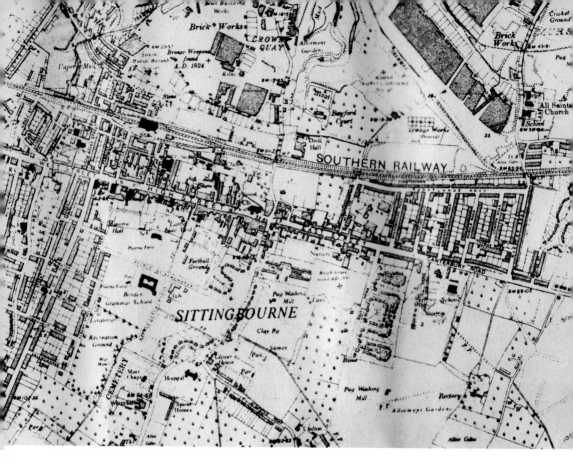

Maps of Sittingbourne

Above: By the mid 1850s the population of Sittingbourne equalled that of its older neighbour Milton. The open space in the right angle formed by Park Road and Watling Street can be appreciated from the opposite aerial shot of this area, viewed from St Michael's Church tower.

Below: Agricultural plots defined on this chart of 1791 show the intensity of cultivations producing food for the local population and, especially, the influx from the coaching trade.

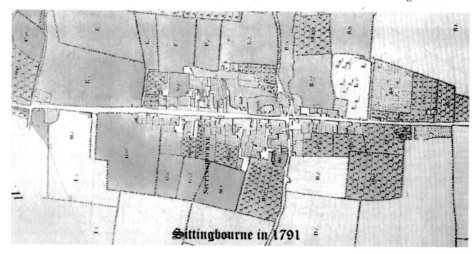

Sittingbourne in 1791

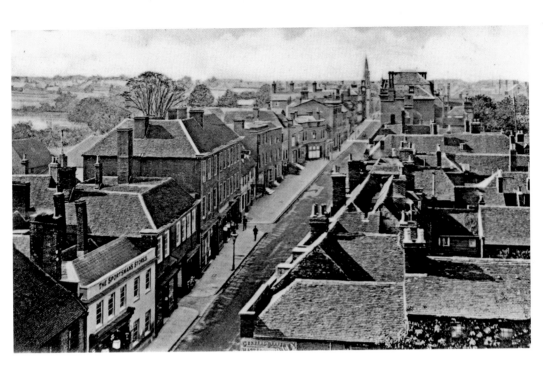

Views Above Street Level
The linear pattern of urban development is clearly displayed here. In the above shot, countryside laps the built environment and contrasts sharply with higgledy piggledy peg-tiled elevations. The carnival atmosphere on the right celebrates Lifeboat Saturday. This was an important local event, bearing in mind Sittingbourne's elemental connection with the sea.

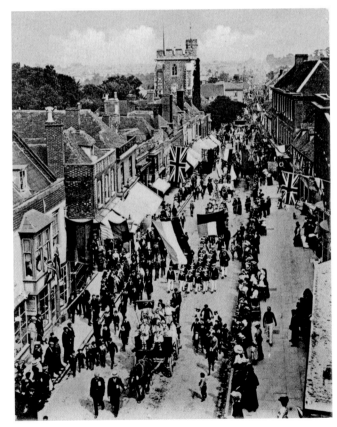

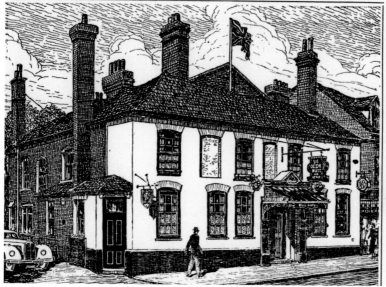

This ancient hostelrie in Sittingbourne, a town founded by the Saxons and set amidst the orchards and hop-gardens of one of the most beautiful parts of Kent, was built over 600 years ago. First licensed by the Monks of Chilham Castle in the 12th century, the property was later bequeathed by the landlord to his wife Annabella in 1368, records of which are registered in Somerset House in London. Today 600 years later you will find good Kentish ales, wines and fare served within these historic walls, and with its twenty-five bedrooms complete with every modern convenience, attractively combines the old with the new amidst surroundings little changed with the passing of the years.

The Bull Inn

The Bull Inn was well placed for custom from farmers and live stock dealers who regularly attended nearby auctions. There used to be a side entrance with a 'buttery' sign above. Some people in their ignorance believed this indicated something to do with the soft edible stuff. However, the term referred to butts, which contained either wine or beer. In the meadow behind pens were erected for animal sales. Now this area has been developed into the Swallows Leisure Centre. It includes a swimming pool, replacing the original one demolished at St Michaels Road or, as it was then called, the Butts, this time referring to an old target practice area for archery.

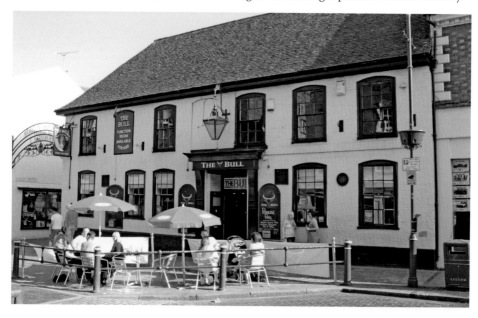

Market Day
Cattle market auctions were a weekly occurrence on land near where Sainsbury's car park now stands. Latterly, Friday general market stalls were erected here before moving to the car park opposite Sittingbourne railway station.

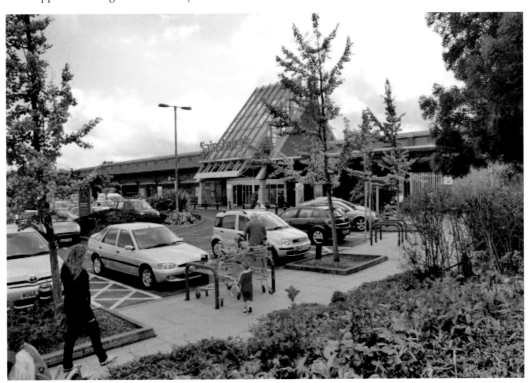

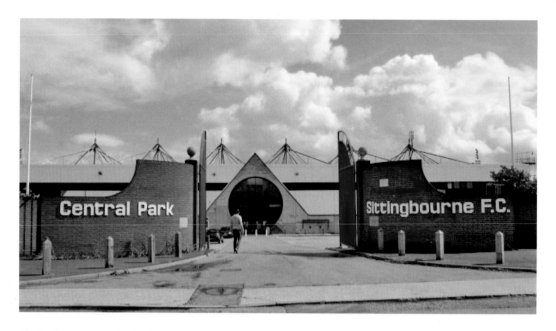

Sittingbourne Football Club

The club moved in the 1990s to its new home at Murston after selling off the Bull Ground for shop redevelopment. The football club found it impossible to finance playing in the new stadium and after just a few years moved to a smaller ground within the same complex. Greyhound racing has continued to this day in the main arena. Pictured below is a team shot from 1936 when past and present players competed in a 2:2 drawn game.

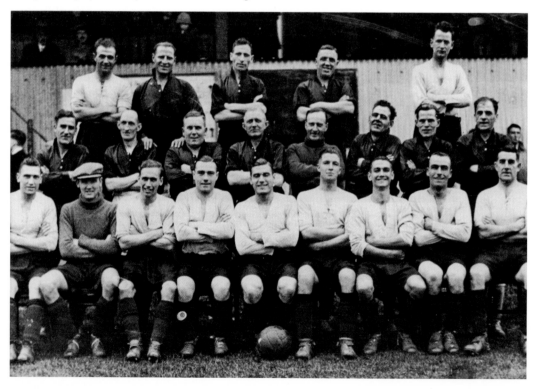

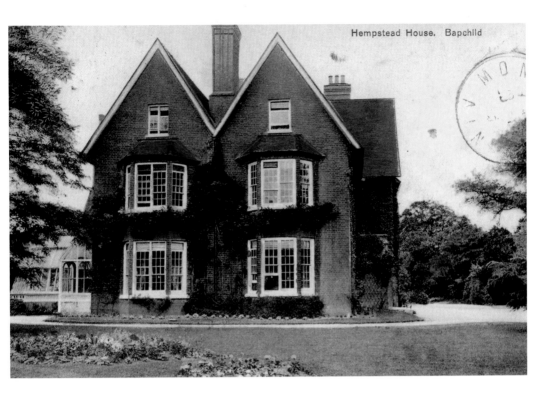

Hempstead House. Bapchild

Hempstead House

This was formerly the residence of a member of the Lake family and has expanded from an inauspicious Bed and Breakfast establishment into the largest Sittingbourne hotel. Before its commercial life began, it was also the home of Sir Leslie Doubleday (local farmer and Kent county councillor). The building expansion in Tesco vernacular style is pictured from the south side as a comparative shot from the front is less revealing.

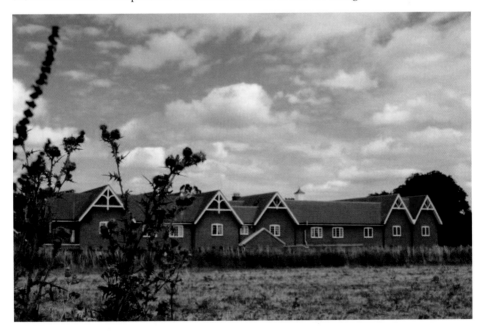

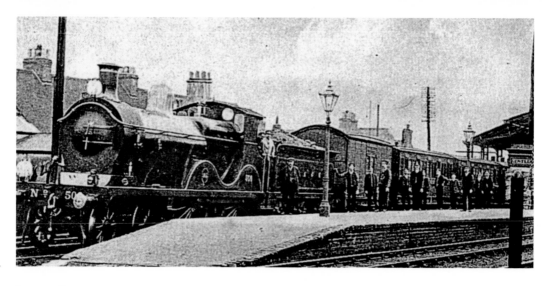

Locomotives

A majestic steam locomotive halted at Sittingbourne on its journey from Ramsgate to London. Over the past ten years, new, comfortable, silent trains like the one below have replaced rolling stock that had been in service for up to forty years. The obsolete slam-door carriages were the motoring equivalent of Morris Minors in an age of computer-managed hatchbacks.

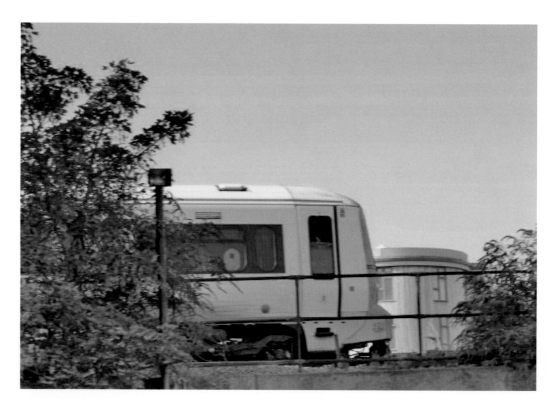

Railway Station

The railway came to Sittingbourne in 1858. It transformed the town and added impetus to industrial expansion. The old sleepy station yard is pictured below in the early 1960s. Vestiges of an earlier age of steam can be identified from the water storage tower on the right of the picture. Due for redesign, the controversial pattern of roads is planned to revert to a more pedestrian-friendly scheme.

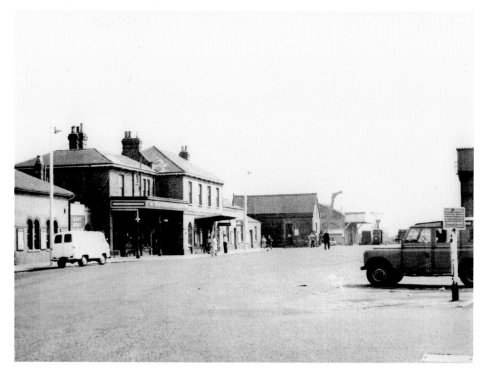

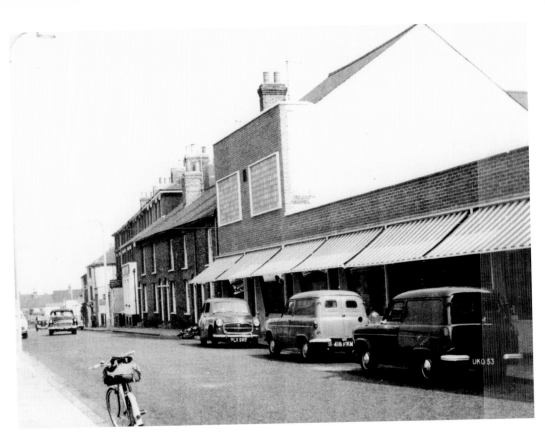

Station Street Looking North
The photograph above was taken in around 1960, after a large department store was constructed.

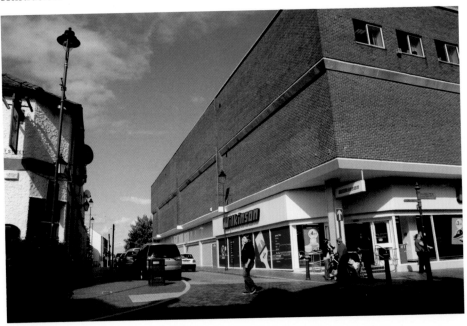

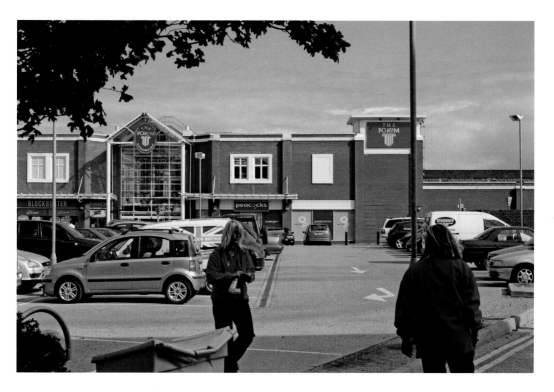

Station Street Alleyways

Today this covers an area which once had narrow roads of Victorian terraces leading onto Station Street. One can see from the atmosphere of this black and white photograph of Station Street in the early 1960s that it was a relatively quiet backwater.

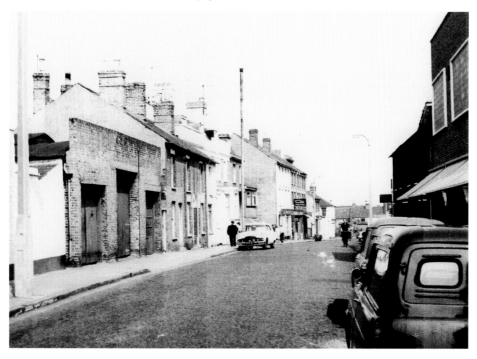

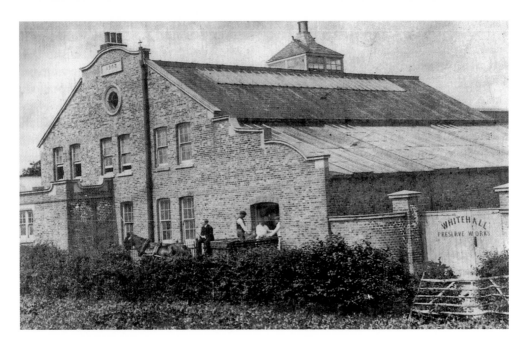

Jam Factory, Bell Road

The jam factory business on Bell Road was originally developed at Woodgate Farm, Oad Street, Borden, where it was run by the Goodhew family. One of their product lines was damson jam, at 25 shillings (£1.25) per hundredweight (112 pounds). Even with fruit sourced from their own orchards, this was a remarkably low price, notwithstanding the ravages of inflation. Subsequently taken over by the Dean family, the business expanded at Bell Road. Part of the remaining buildings are now used for offices. Nevertheless, its early development in what was then the countryside, can be identified by the Oast House structure once used for drying hops.

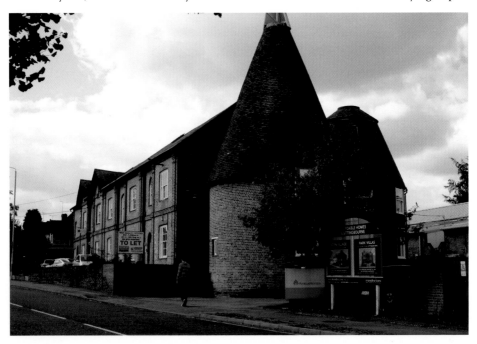

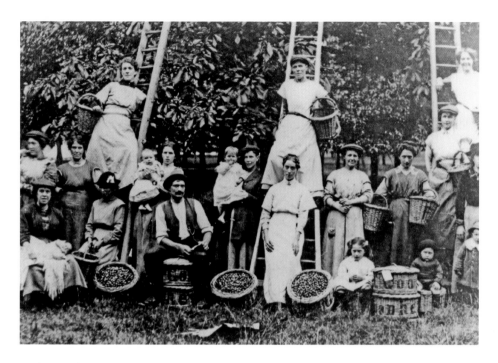

Fruit Growing

The pot lid illustrated here is a relic of Victorian packaging. Loads of these products were sent by horse-drawn transport to the firm's in-house barge and onwards to a warehouse in London. These pickers are seen in a Goodhew plantation at harvest time. Tall trees were then *de rigeur* with heavy, unwieldy ladders used to access the highest crops. Cherries are still grown in this area, following a tradition inaugurated by Harris, King Henry VIII's fruiterer. However they are produced on trees with short tree trunks and invariably under metal frames for protection from weather and birds.

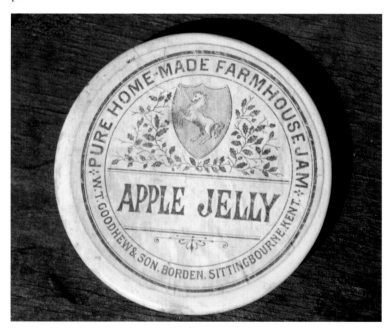

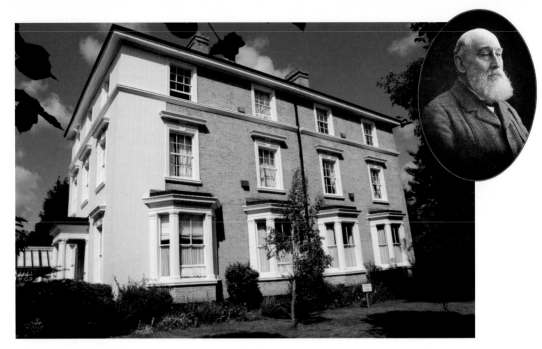

Whitehall, Bell Road

This was the home of George Dean – local entrepreneur and business associate of George Smeed. Their multifarious enterprises brought much prosperity and employment to Sittingbourne. When the future George VI visited this corner of Kent, he was entertained to lunch here with local worthies. An amusing anecdote from this historic day survives. It relates to a new toilet which was installed for this special occasion. Somehow the Duke, to the mutual embarrassment of all concerned, managed to trap himself in this new 'convenience'. A substantial construction, this building has subsequently been utilised by the local authority for office accommodation. Now it is sub-divided into attractive flats.

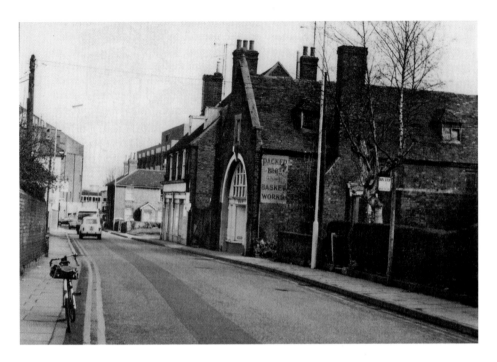

Bell Road

Two generations ago this comprised Featherstone's department store, The Bell general store, the Three Kings public house, a stonemason's, Nash's furniture store, and Gilham's shoe menders. The west side has been taken over entirely by sheltered accommodation provided by McCarthy and Stone. The opposite side of Bell Road is mostly the Bell Centre which consists of shops and offices. Gone but not forgotten are Packer Bros who were basket manufacturers. Their premises were attached to the Bell General Store and their output of hand-crafted wares were essential purchases for many of the indigenous fruit growers.

The Crossroads between East Street and High Street
This was where casual labourers used to assemble to be hired for day work. Often this employment would involve tasks at the docks associated with Thames sailing barges at Crown Quay. The late Ernest Cook of Rodmersham Green once recalled how he was paid 2 shillings (10p) for loading a barge with bricks at the depth of the inter-war economic depression. It is now a very busy traffic junction due to the close proximity of Swale Borough Council offices and the extensive Eurolink Industrial Estate. The Odeon cinema in high Art Deco style can be glimpsed in the top right of the present picture. It replaced a large shop called The London Bazaar with awnings which extended over the pavement.

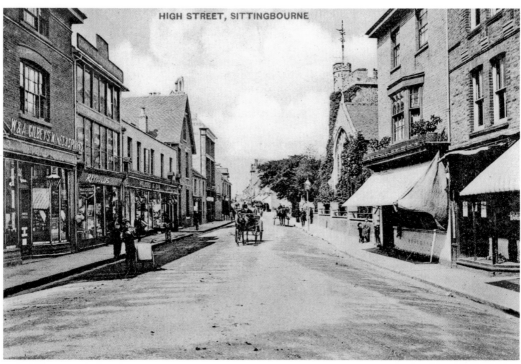

HIGH STREET, SITTINGBOURNE

St Michael's Church

St Michael's Church has served the community since perhaps Saxon times. Its present structure is a typical amalgam of medieval styles. In the late eighteenth century a devastating fire destroyed the roof. Thereafter it took many years for the town's congregation to fund restoration. Used now for regular weekly worship, this church continues to be a true flagship of the borough. Sadly, the fine vicarage below has disappeared to make way for new developments relating to St Michael's Road.

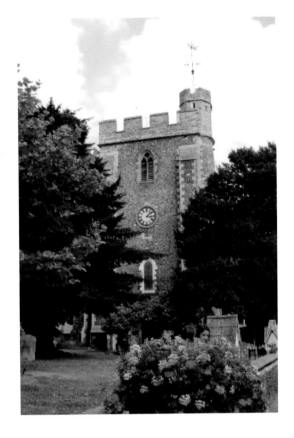

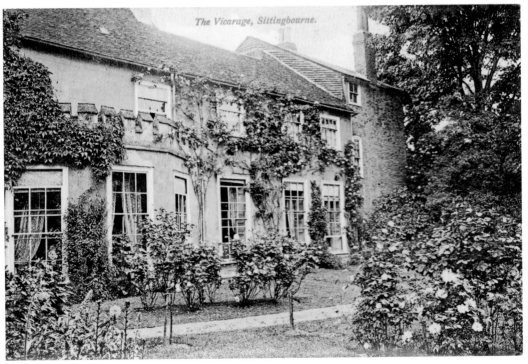

The Vicarage, Sittingbourne.

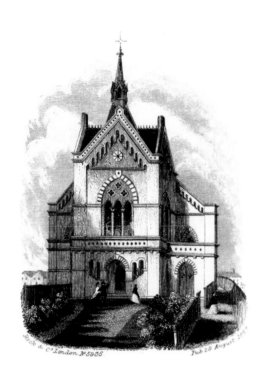

The Methodist Chapel
The chapel, pictured here in its original neo-Lombardy style, was a victim of incendiary bombs during the Second World War. It was an opulently furnished building, erected near the site where John Wesley preached on three occasions. The building shown below is the 1952 replacement.

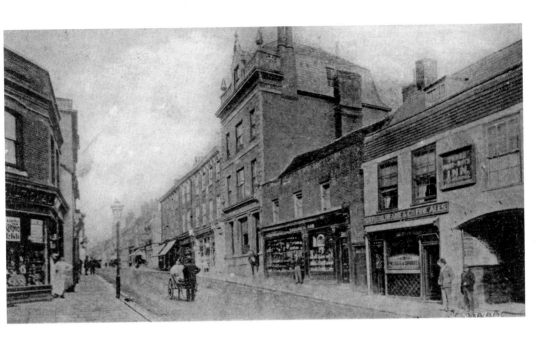

The Old Westminster Bank

The bank, with its shiny mahogany counters, used to operate from the buildings in the centre of this picture, before moving to the town hall site. For many years the baker's and cafeteria, run by the Barrow family, have been a convivial respite for shoppers. The gap in the buildings is the entrance to the Methodist Chapel.

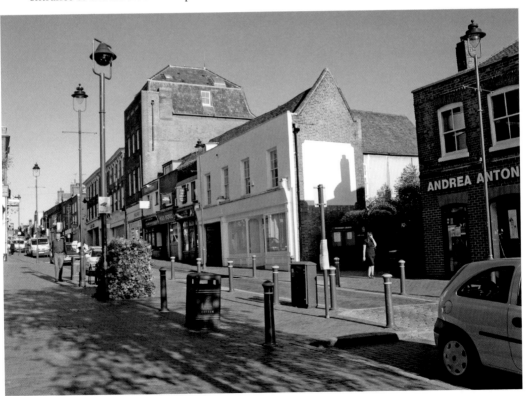

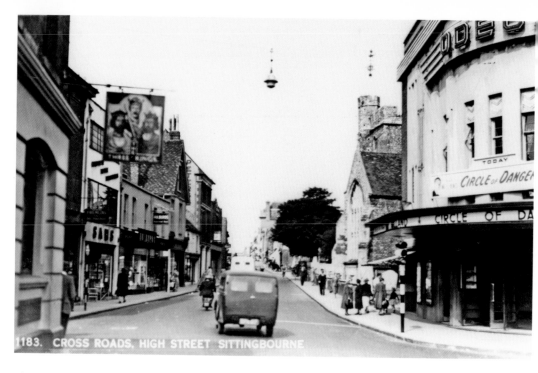

1183. CROSS ROADS, HIGH STREET SITTINGBOURNE

The Odeon Cinema

The Odeon Cinema was the last of three picture houses to close its doors on Sittingbourne film lovers. First to shut was the Plaza in East Street, followed by the Queen's nearer the main High Street.

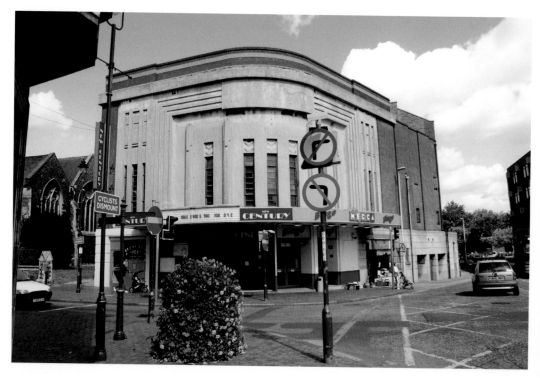

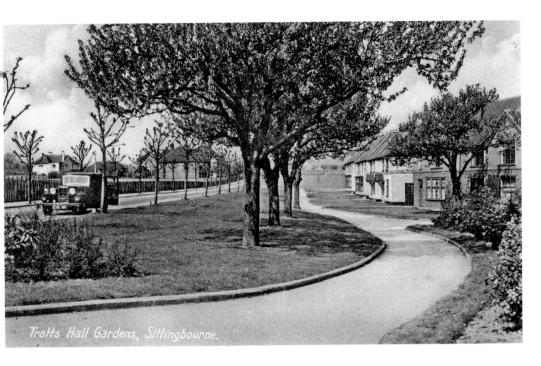

Trotts Hall Gardens, Sittingbourne.

Remembrance Avenue

Trotts Hall estate was, as the name implies, built within the grounds of a larger residence. Due to redevelopment needs, this house was taken down brick by brick and remade in the grounds of Milstead Manor. It became a retirement home for the renowned local businessman, the late Rex Boucher. The avenue of young trees to the left commemorates servicemen fallen in the Great War. They have been replaced to accommodate widening of the roadway following a Sainsbury supermarket superseding Bull Ground football pitch (previously the home of Sittingbourne Football Club).

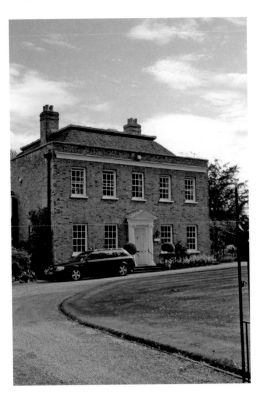

Trotts Hall
The photograph below was taken during the hall's reconstruction and adjacent with established gardens. The local builder, Butcher, was responsible for this skilled operation.

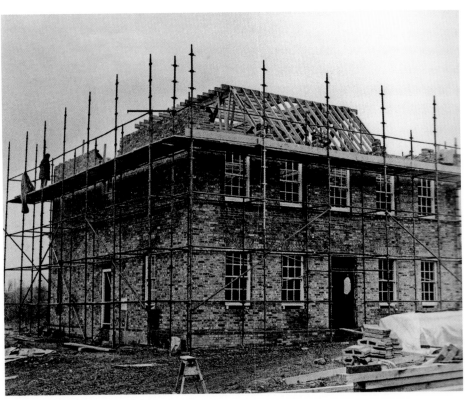

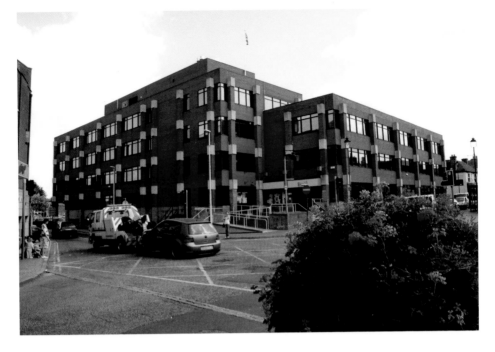

Swale Borough Council

Swale House is the home of Swale Borough Council. It was built as a speculative office development for prospective firms seeking relocation from London, and a generation ago it was adopted by the district local authority, centralising its widespread administrative bases (such as those below in Central Avenue).

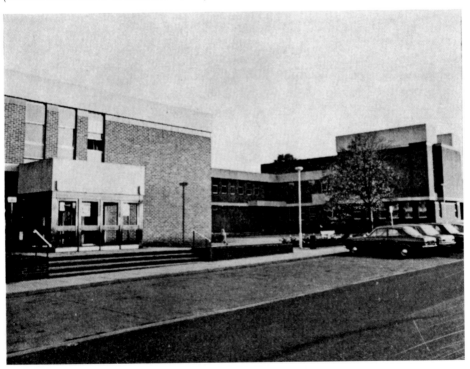

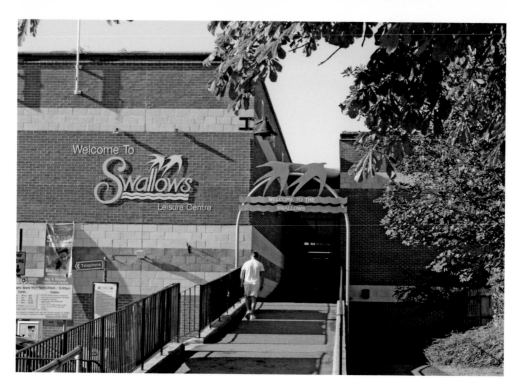

The Swallows Leisure Centre

The leisure centre incorporates a swimming pool along with a gym and squash courts. It was provided by Swale Borough Council in the late 1980s to replace the old Victorian baths, pictured below. They were installed in 1896 and hired hot baths to people without such amenities in their homes. The establishment costs were greatly assisted by a donation from Frank Lloyd — philanthropist and esteemed paper mill proprietor.

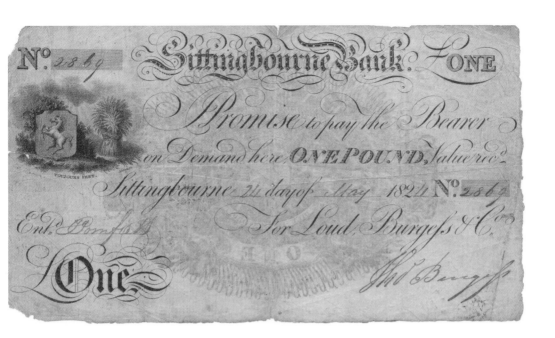

Banking, Still Vulnerable to Failure

A Sittingbourne bank note from the Regency period is displayed here. The joint stock bank issuers failed in 1824. Its partners were Loud Burgess and Co. Thomas Burgess has signed the currency. On the reverse there is an unusually intricate design of a vignette by Ashby and Co. Bank of Scotland's new banking hall is photographed here in the High Street. Its style blends in well with its surroundings. Shareholders have been joined by the government who also brokered a liaison with a stronger partner as the credit crunch impacted.

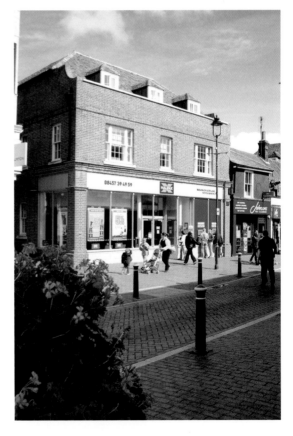

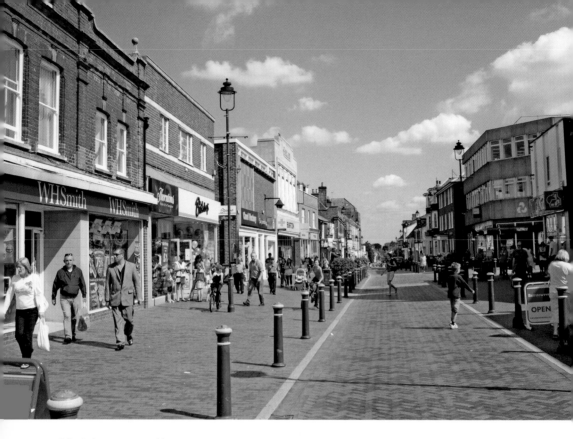

Mid-High Street Looking East
The Old Town Hall or Corn Exchange, as it once was, has been replaced by the National Westminster Bank. Buildings attached to its west side were knocked down to provide a roadway called Central Avenue.

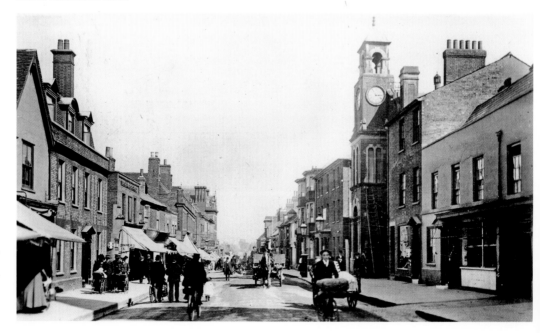

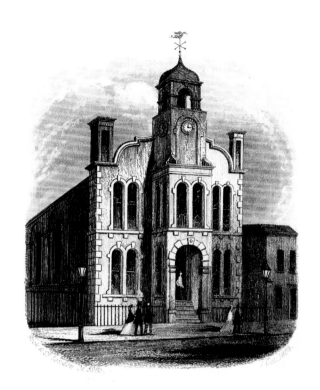

The Corn Exchange
The Corn Exchange, illustrated in this fine Victorian lithograph, which became Sittingbourne's first town hall and shows off an excellent style of architecture synonymous with British nineteenth-century strength and confidence. By contrast its replacement is unremittingly bland and of little design merit.

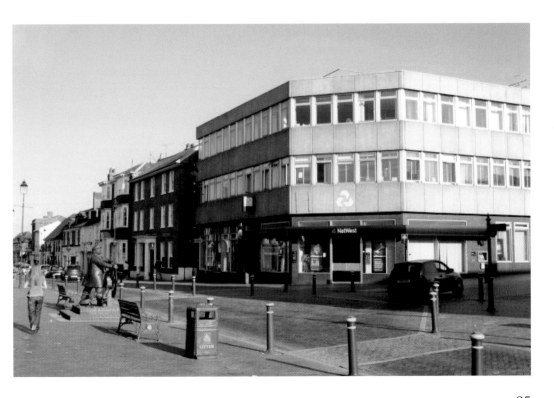

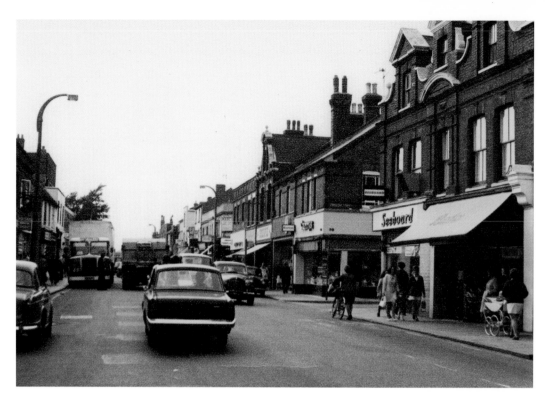

The Mid High Street looking West

This view is remarkably unchanged since the 1960s — save for the nature and merchandise of the various shops. Looming above the skyline in a recent photograph is the department store built by the Co-operative Society. This emporium on the corner of Station Street has been taken over by a discount store, namely Wilkinson's.

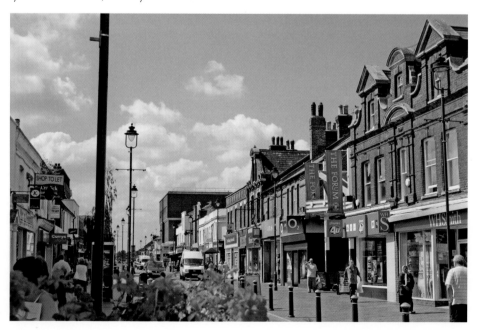

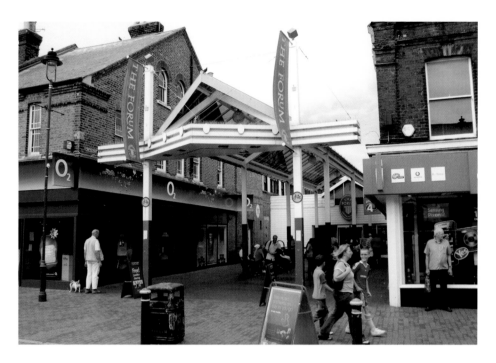

Crescent Street, Looking North-West

Crescent Street used to link the High Street with the railway station. The Forum shopping centre now occupies this space. In the photograph Wicks, the local baker's, is on the corner site. Further down there was a television and radio repair shop. Before the corn exchange became the town hall, assembly rooms and municipal offices jostled with the library here. As a reflection of the current age, both corner sites now house mobile phone shops.

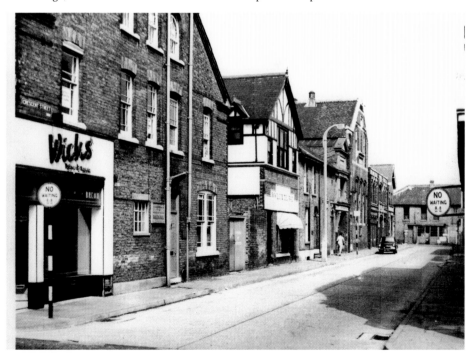

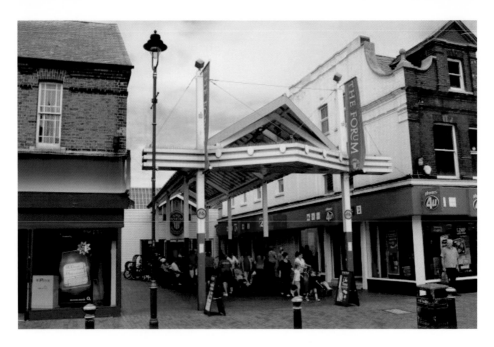

Crescent Street, Looking North-East

On this side of the street an electricity supply company had a showroom. Adjacent to this, concealed behind two wooden doors, was Harry Down's garage. This was a one-man band outfit with an Esso fuel pump dispensing fuel at below 5 shillings (25 pence) a gallon.

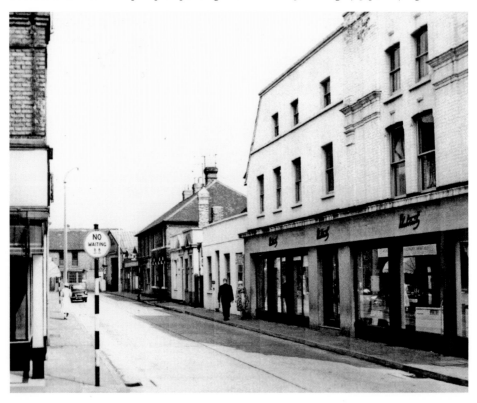

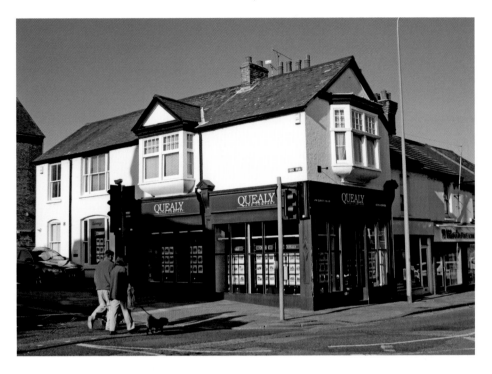

The Junction of Park Road and West Street

Estate agents now abound in this section of West Street. Quealy and Co is a leading local firm and now occupies premises used initially by a photographer and then a pharmacy. In both shots you will see a space in the building line caused by bomb damage in the 1940s.

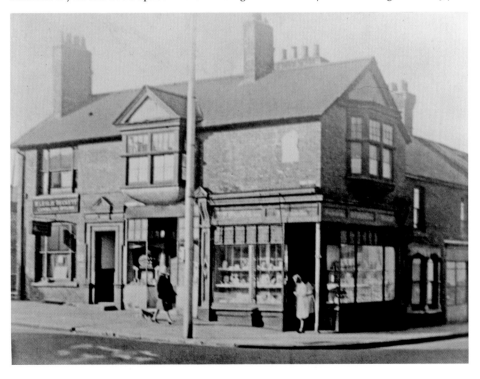

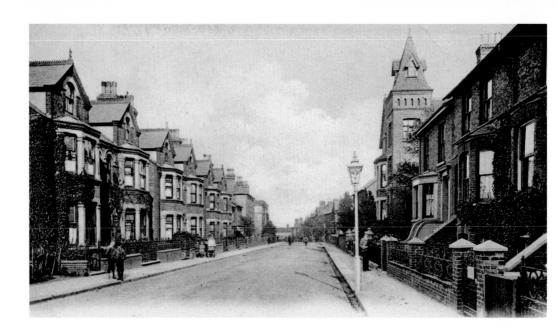

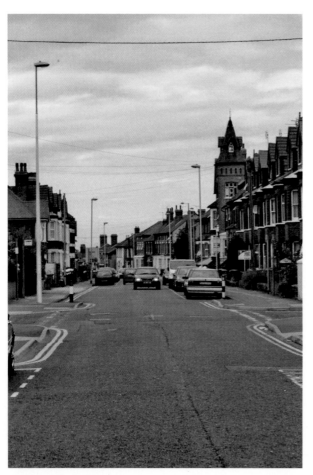

Park Road

This road was so-named as it led southwards from the town centre to Gore Court Park, and is shown here as the wide highway intended by its constructors. During the past two generations its passageway has become constricted by parked cars. The elegant turreted building to the right was the villa of brick maker Daniel Wills. Apocryphal stories of the tower's use as a look-out for spying on the approach, through the creek, of the owner's sailing barges have become common folklaw. For many years the building has been used as offices for local land agents.

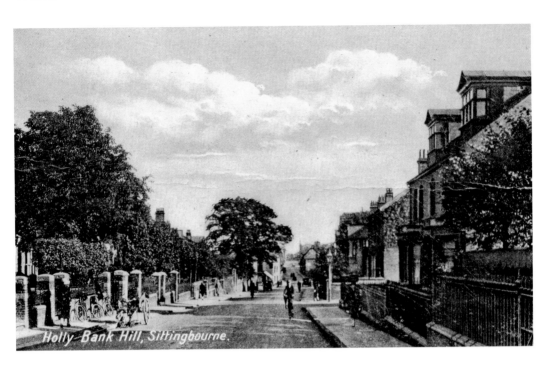

Holly Bank Hill

Holly Bank Hill on the main road going westwards towards London is not tarmacked in this old postcard image. Some of the larger Edwardian villas are currently divided into smaller homes. Also, there are a number of dentists, doctors and other professionals' consulting rooms to be found in this area of Sittingbourne.

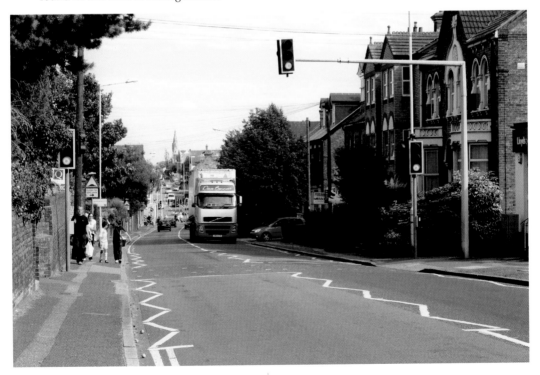

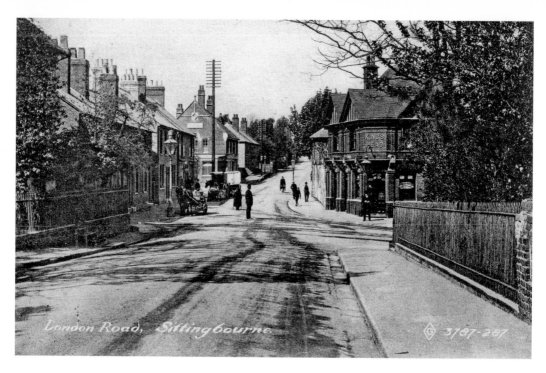

Chalkwell

Chalkwell was, before the Industrial Revolution, a separate community from Sittingbourne. It was known for its tannery — one of several in the vicinity. Also, a windmill once ground corn on the nearby hillside. The iron railings on the right of the picture above have now been replaced by a wall, concealing a sheltered housing development. Meanwhile, the King's Head public house, prominent on the corner, remains as a club.

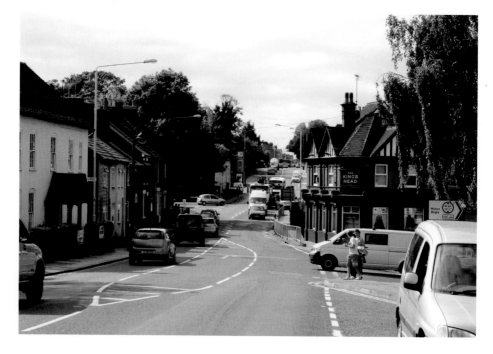

Borden Grammar School
The entrance to Sittingbourne's Borden Grammar School for boys. It is only one of a hundred or so left after the comprehensive system became more universal. Established at Remembrance Avenue in the 1920s, the redundant building continued to be used for educational purposes by the Kent Farm Institute first, and then as an adult teacher training college.

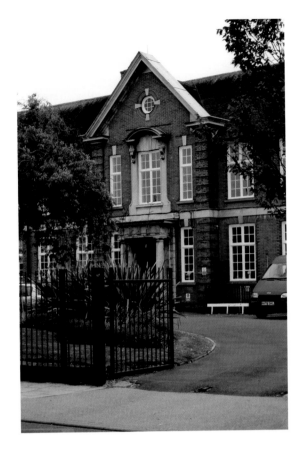

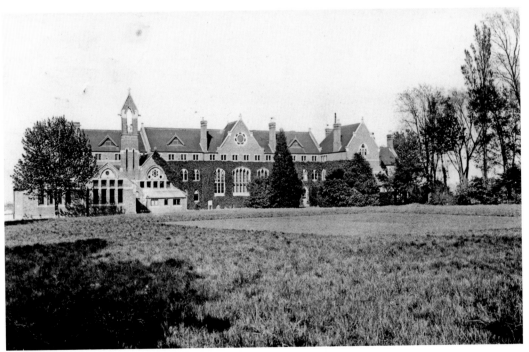

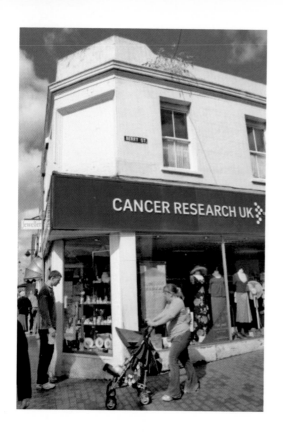

May & Sayers' Outfitters Shop
Outfitters May & Sayers' initial premises were on the corner of Berry Street. Expansion presaged a move to a shop with larger floor space at No. 100 High Street. In the 1950s quantities of school uniforms were sold — wrapped expertly in stiff brown parcel paper, bound with strong string. Cancer Research UK have an outlet here, one of a variety of the town's High Street charity shops.

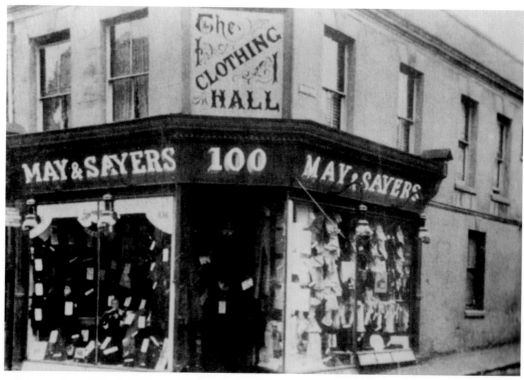

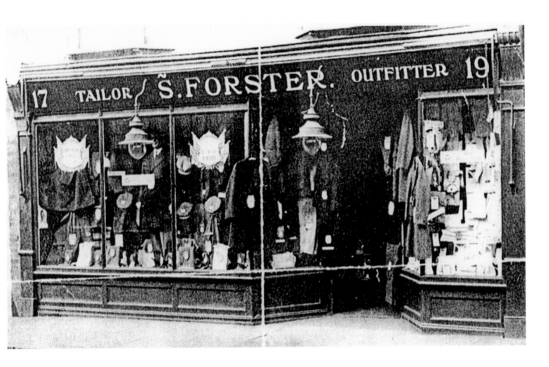

Forster's Shop, East Street

Forster's is one of the few family-owned businesses left in Sittingbourne. Started in 1931, the shop is a major supplier of school uniforms. Its earlier history was as the Bourne Inn (one of the many coaching inns along this section of Watling Street). Seen standing is proprietor Mrs Doreen Williams née Forster.

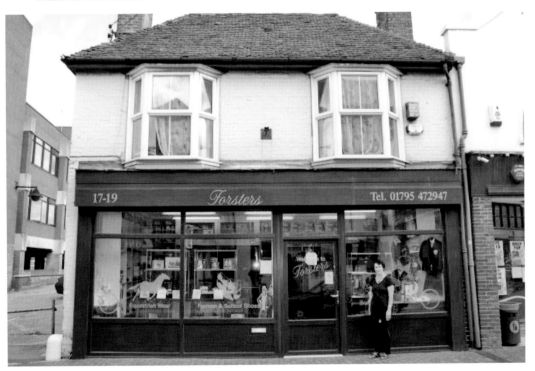

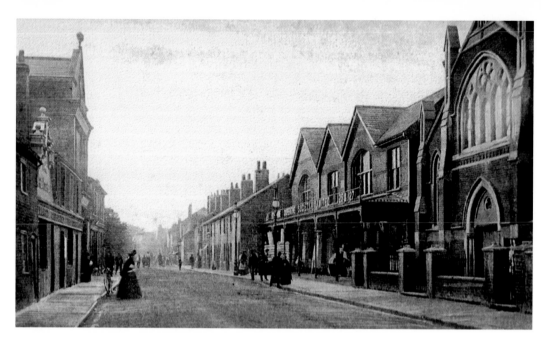

Phases of Development in East Street

Above is a view of the original graceful Victorian buildings. Below, this well-appointed set of function rooms was erected on the previous site of Co-op stores. Aldi's supermarket in East Street replaced the short-lived Regis Suite (inset).

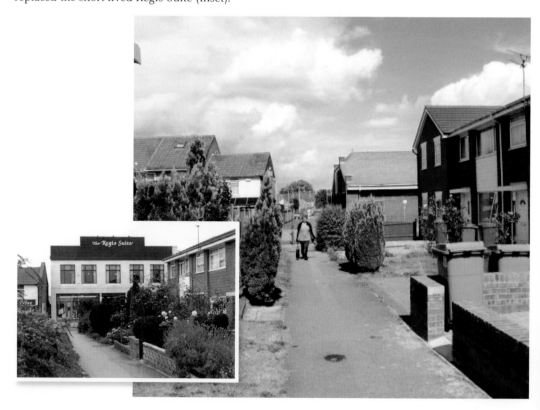

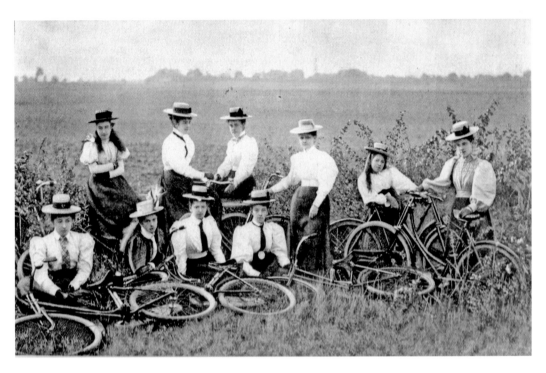

Pastimes

Rammel, the leading Sittingbourne photographer, took this snapshot of late Victorian young ladies out cycling for recreation. A go-karting circuit on the Eurolink estate is now a venue for more contemporary fun.

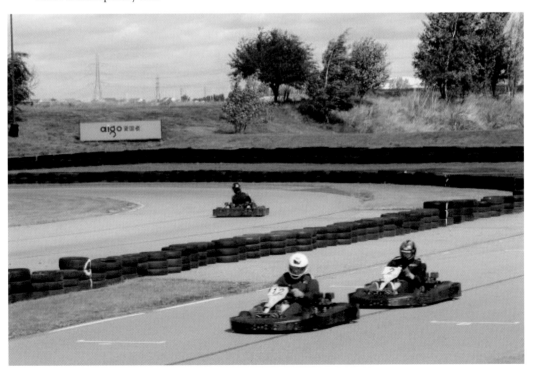

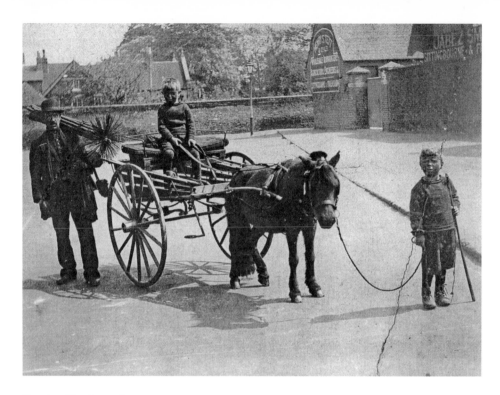

Heating 'Engineers'

A chimney sweep with his two grandsons at the Butts, Sittingbourne. This is a masterpiece of photographic genius. It is deliberately placed above a lifeless vehicle belonging to a reputable heating engineer of today, thereby focusing on the stunning image of human poignancy.

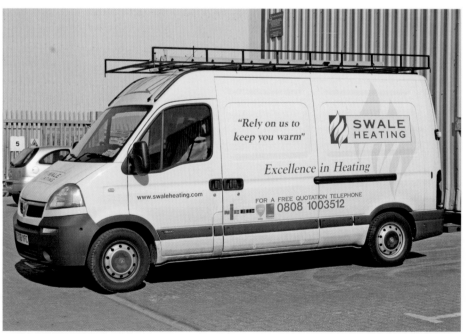

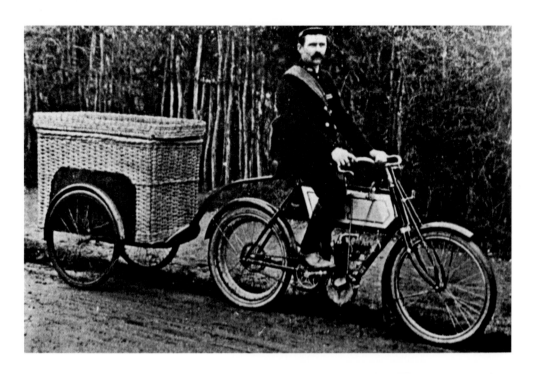

Two Postmen who Served Sittingbourne

A local postman is seen above astride his motorcycle. He pioneered the motorised postal delivery service between Teynham and Sittingbourne. In a similar but more relaxed pose is retired postman Dale Howting. He has over the past thirty-two years raised well over £200,000 for local charities. This well-liked character is known universally to locals as the whistling postman.

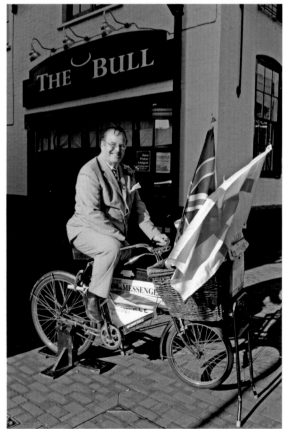

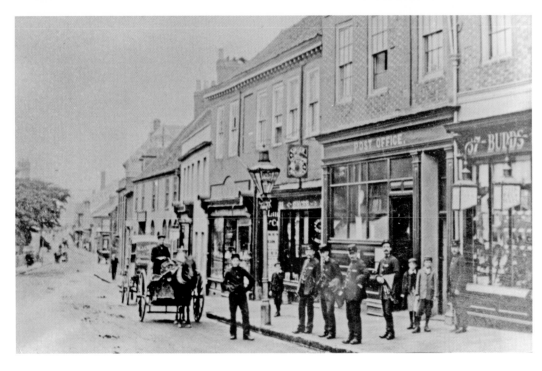

Old Post Office

Sittingbourne post office has had at least three sites. This early one in the High Street is pictured with uniformed postmen posing for a photograph. Blundells have for many years used this handsome Georgian building as a furniture showroom.

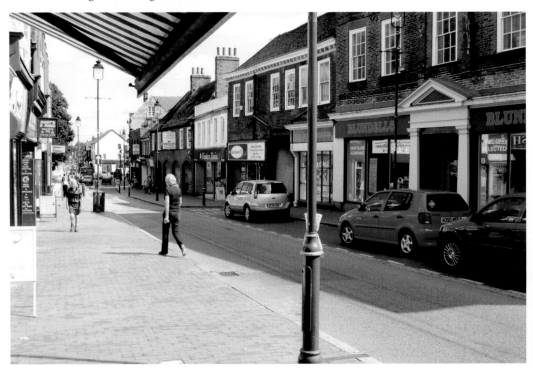

Sittingbourne Post Office

Sittingbourne post office, Central Avenue, with busy delivery staff on a sunny summer morning. Its location here was part of an overall plan devised by visionary local authority executives under the aegis of Donald Allan. The somewhat fuzzy image on the right is of the old High Street post office which served Sittingbourne for the first half of the twentieth century.

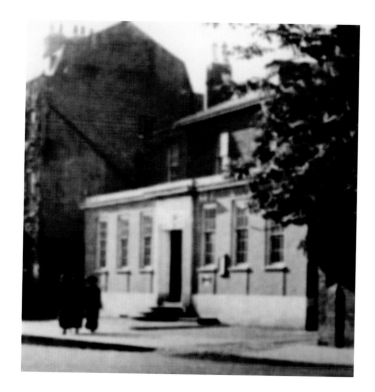

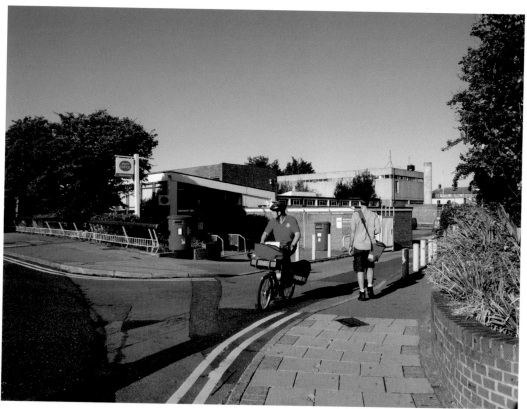

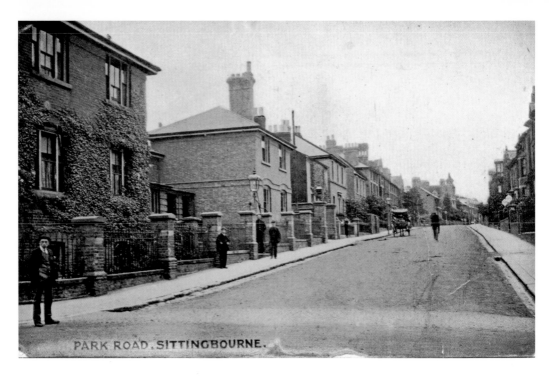

PARK ROAD. SITTINGBOURNE.

The Police Station

The old police station in Park Road has visibly changed little over the years. Without the blue lanterns it is now a magistrate's court. The local constabulary have relocated to Central Avenue to a site which includes a building previously used by the Inland Revenue.

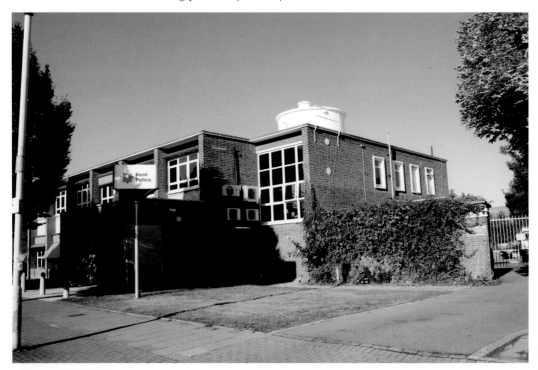

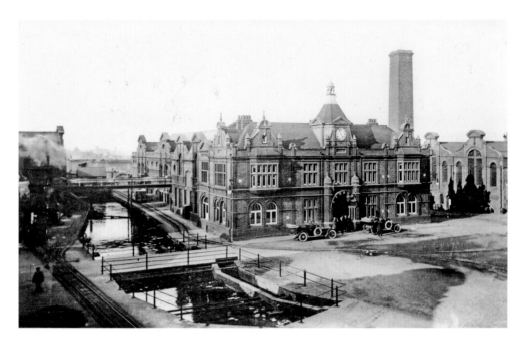

Sittingbourne Paper Mill

Paper manufacture had been a principle industry of Sittingbourne for over 300 years. The factory above has been owned by Lloyds, Bowaters, Fletcher Challenge, and lastly before closure, M-real. In the days of Edward Lloyd, large chauffeured cars are seen waiting for their passengers. Below, the listed building remains devoid of human activity.

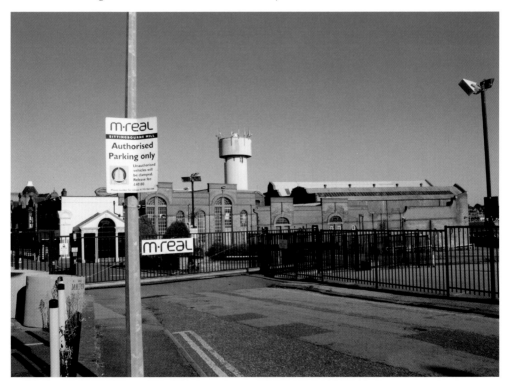

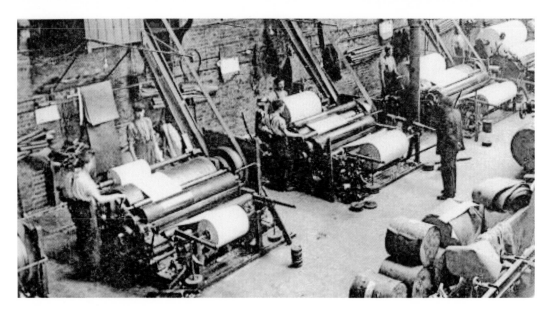

Paper Making

Early machinery used to produce paper for Edward Lloyd's *News Chronicle* Fleet Street newspaper. Below, rags used in manufacture were stored in these sheds. Later, steam trains replaced horse-drawn carts.

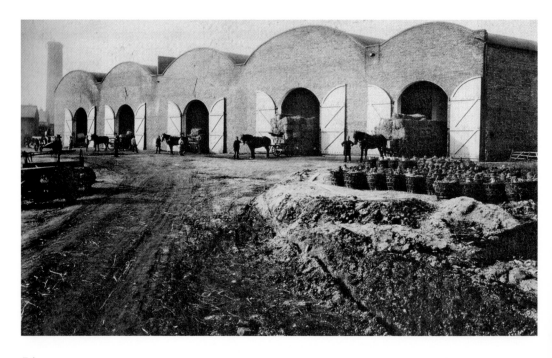

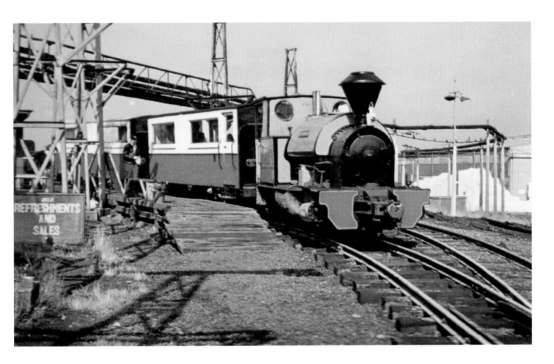

Kemsley Light Railway

A steam railway track was installed to link the old Sittingbourne paper mill with a new factory at Kemsley and its adjacent dock. Logs from around the world were imported and moved inland for crushing. Also, employees used the train for transport to work. Now a vital part of Sittingbourne's past industrial heritage, the Kemsley Light Railway is preserved in excellent condition. There is currently a campaign to guarantee its long-term future, called S.O.S. (Save our Steam Railway). The viaduct is also worth mentioning as this is one of the earliest examples of the use of reinforced concrete.

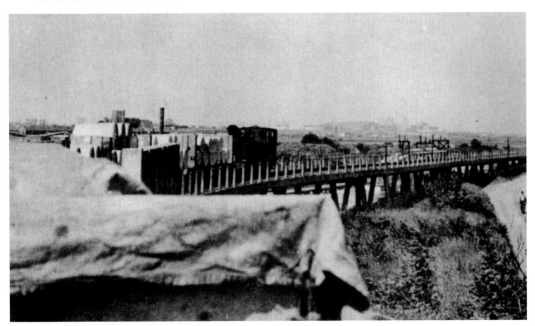

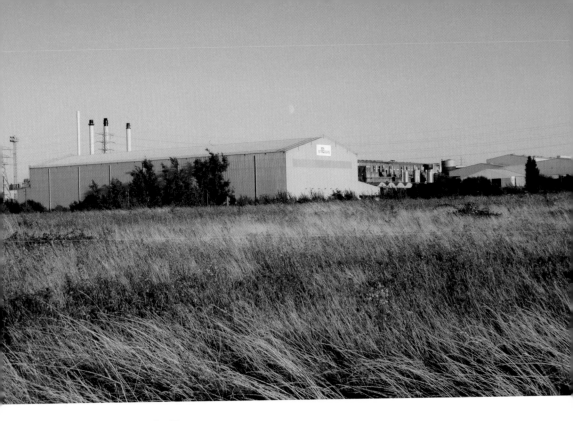

Kemsley Paper Mill and Village

Kemsley Mill was the brainchild of Frank Lloyd and was a massive economic undertaking. Power for its energy use was generated from its own steam turbines. To accommodate a legion of employees this model village below was built nearby. It was laid out in the then-fashionable Garden City style.

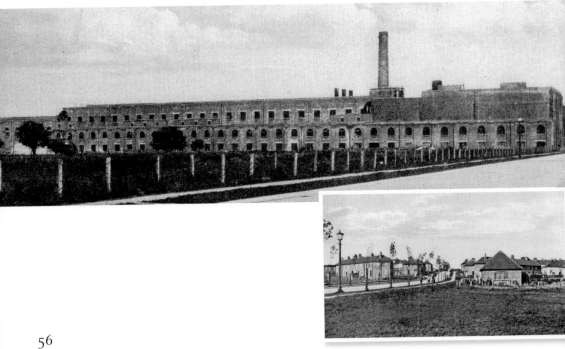

Milton Creek

Milton Creek with Thames sailing barges moored awaiting their myriad cargoes of corn, bricks, paper, cement and fruit preserves. Return journeys from London often brought loads with the sobriquet 'rough stuff'. In reality this terminology was a euphemism for the dung and detritus removed from the horse-trafficked, metropolitan streets. Like the modern idiom, it was recycled in the production process of brick making. Pleasant walks can be enjoyed along the footpaths of this ghostly waterway where over ages Roman vessels and Saxon and Viking invaders have gingerly probed the interior of north-east Kent.

Paying homage to past glory, a statue of a typical local bargee was unveiled by the Mayor Councillor, Don Jordan, when the High Street was partially pedestrianised in the 1990s.

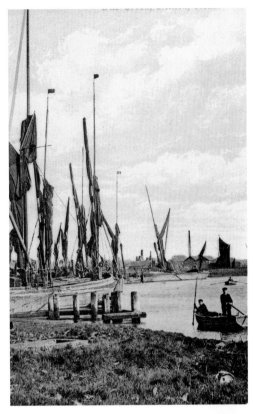

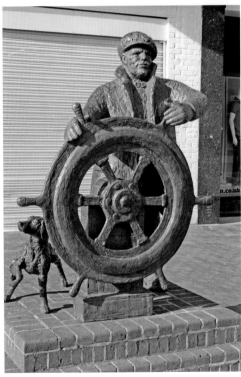

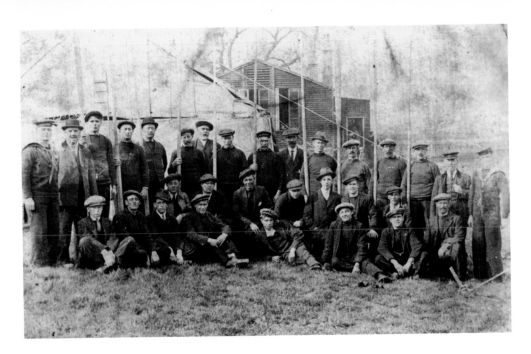

Bargees

Sittingbourne and Milton bargees formed two mutual organisations at the height of the boom in this occupation. The first comprised some 500 members and was known as Unity Lodge No. 2. Meetings were held in a hut on the butts. Their motto 'defence and defiance' implied a somewhat militant nature. Not surprisingly labour organisations were becoming more necessary as witnessed by a dock strike of 1889 when a rate of pay of 6*d* (2½ pence) per hour was successfully negotiated. The vicar of St Michael's, Revd Harry Evans, led an organisation called the Bargemen's Brotherhood. Its motto was 'hold fast' which was an excerpt from the full biblical legend 'hold fast the good, stand by the better yet'. The 150 members were entitled to fly a pennant on their vessels carrying the letters BB.

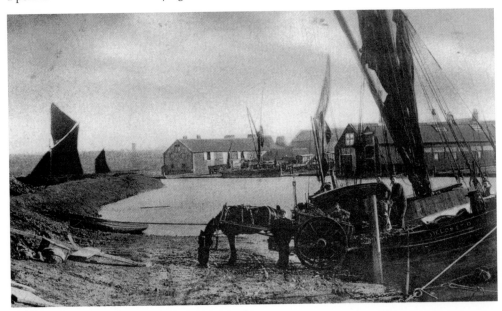

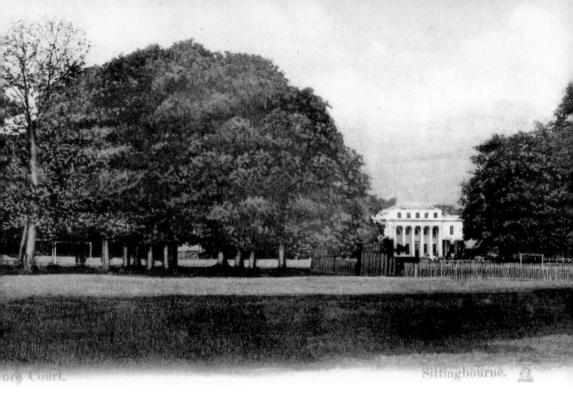

Gore Court Mansion

Gore Court, the seat of George Smeed. This self-made industrialist was a local legend. The mansion has gone save for the bases of classical columns from the front elevation. A snapshot of one is set against the picture below of the surviving stable-block. This now serves as an amenity building for what has become King George's playing fields.

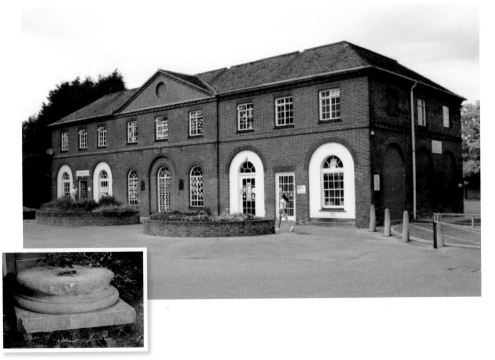

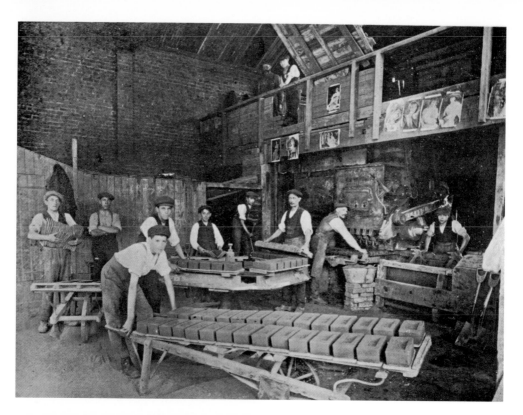

Brick Making

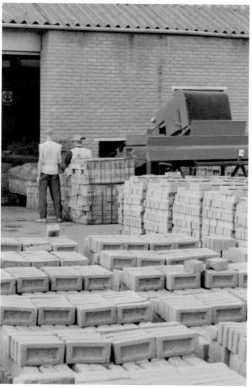

Brick manufacture was such a pervasive occupation in Swale that the town football team are still known as the 'Brickies'. Smeed Dean's most renowned product was yellow stock bricks. Their colour derived from a mixture of local loam and chalk. Deposits of these raw materials were mined from the surrounding countryside and they often overlaid each other geologically. Characterised by extreme strength, Smeed Dean's stock bricks had the marvellous propensity to increase in strength with age. They can still be seen widely utilised in large areas of London and its suburbs where the shade has become somewhat dulled with air pollution. The above team are making hand-crafted red bricks under the supervision of a moulder. Seen left are the results of modern mechanised production methods at Murston.

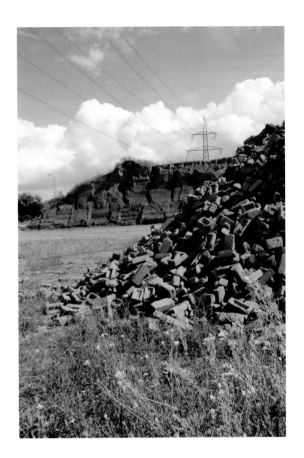

Brickies' Outing

Local brick workers of yesteryear would recognise this recent picture of reject bricks in front of a pile of excavated brick earth. In the shot below, however, they have their minds on some well earned recreation as they eagerly prepare for an outing on a double-decker bus.

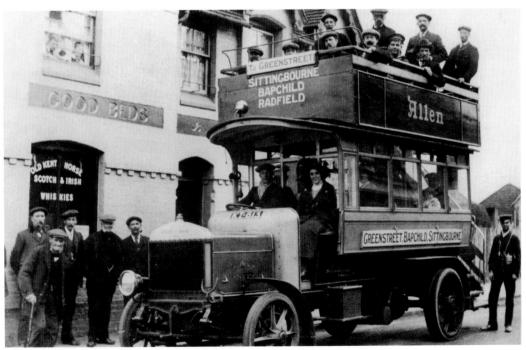

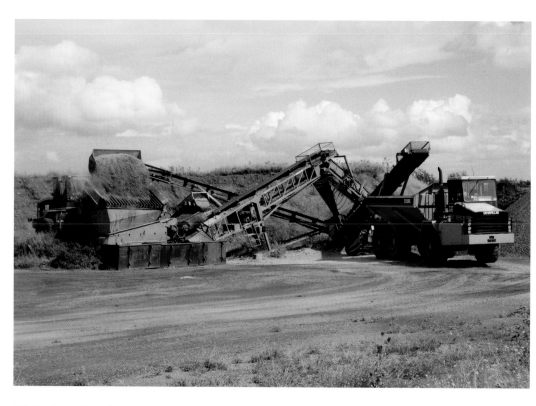

Mixing Raw Materials

In the photograph above is a mobile plant for mixing ingredients to be made into bricks on the Eurolink Estate. Below is the pumping station at Highsted Quarry in its heyday.

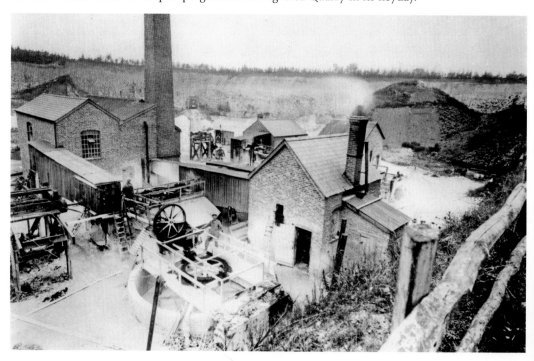

Cement Industry

Building materials from the Sittingbourne area are a tradition that continues unabated. Although cement is no longer manufactured, the ubiquitous output from Milton Pipes can be found in surprisingly far-flung corners of the globe. In the past quantities of chalk were quarried at places such as Highsted. After mixing with water this crushed stone was piped to tanks to be combined with dissolved clay. Marshland around Conyer and Murston were well known for supplying this 'pug'. A faded image below shows men loading trucks with this heavy mud for a tramway going into Conyer cement works. The predominant local factory location was Eastwood's cement works in Murston.

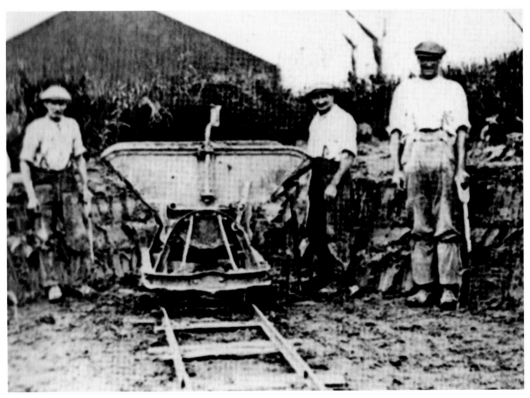

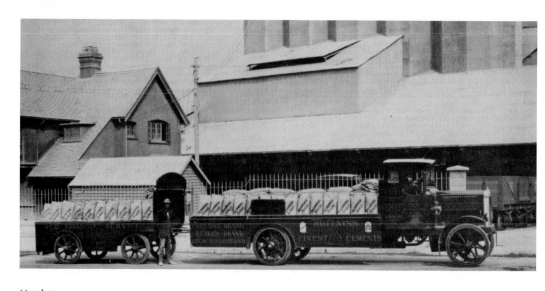

Haulage
Heavy lorries are still needed to take finished goods to wholesalers and construction sites. Above, enormous sacks of cement, and below gigantic concrete pipes head off for the highway.

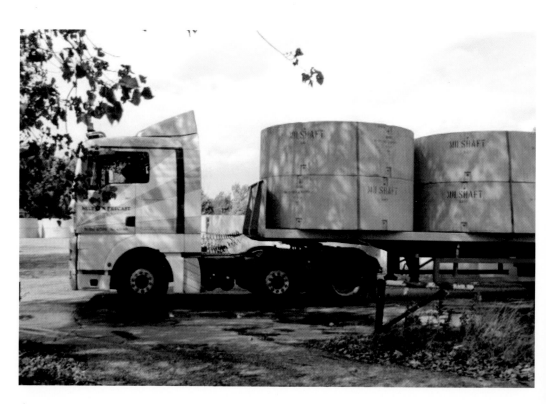

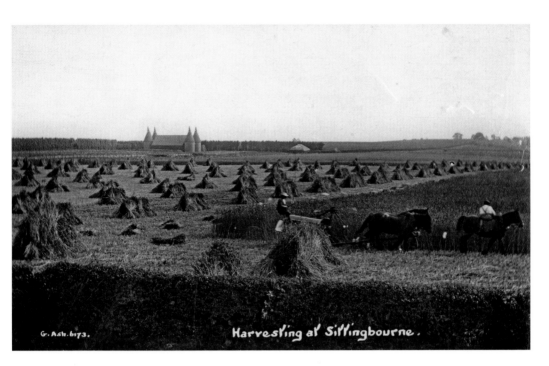

G. Ash. 6173.

Harvesting at Sittingbourne.

Harvesting Near Sittingbourne

Farming has always been a significant economic activity in the Swale area. Sittingbourne is placed in the middle of the North Kent Horticultural Belt. A good climate, fertile soils and a nearby metropolitan market have been favourable factors. Within living memory sheaves of corn were harvested for threshing later after careful storage in neat stacks. Leviathan machines now combine cutting and threshing and leave nothing but dust and particles of straw in their noisy wake.

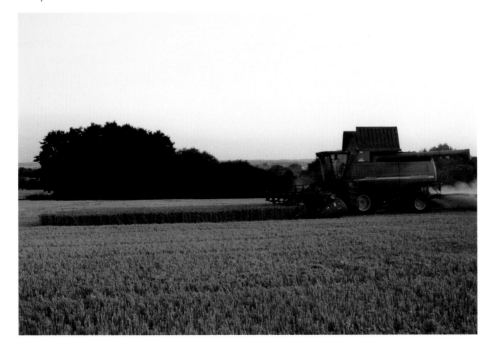

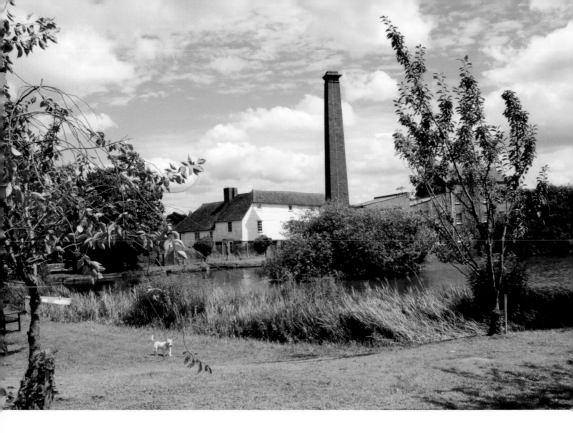

Tong Mill

Tong Mill is one of four Conservation Areas illustrated in this volume. Its classification is a vital protection as urban sprawl creeps inexorably closer. Once the site of a Saxon castle, this unchanging gem of the Kent countryside is fortuitously surrounded by countryside park, generously provided by its long-term owners, the Wicks family.

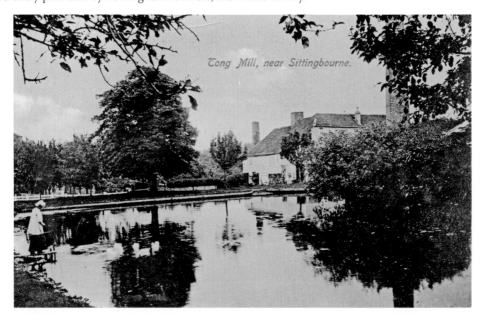

Tong Mill, near Sittingbourne.

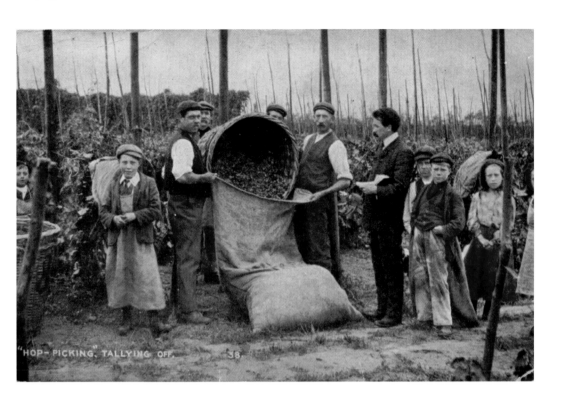

"HOP-PICKING" TALLYING OFF.

Hop Pickers
Dorothy Francis helping towards the harvest at Broadoak Farm, Milstead. Pictured in her childhood, she became a very much respected member of her local community and enjoys participating in village activities to this day (her 96th year).

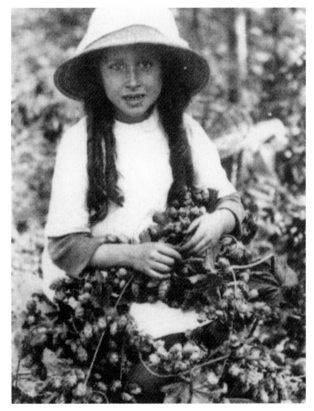

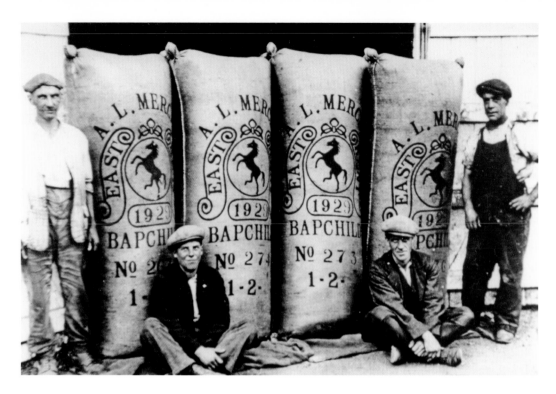

Hop Fields

Hop gardens have all but disappeared from the Swale area. Their huge significance can, however, still be gauged from the large number of surviving oast houses. Mostly these have been converted into desirable country residences.

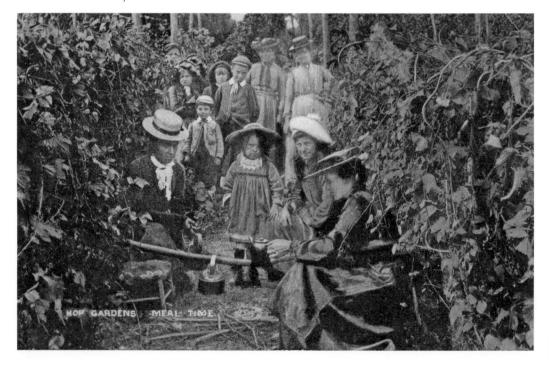

HOP GARDENS, MEAL TIME.

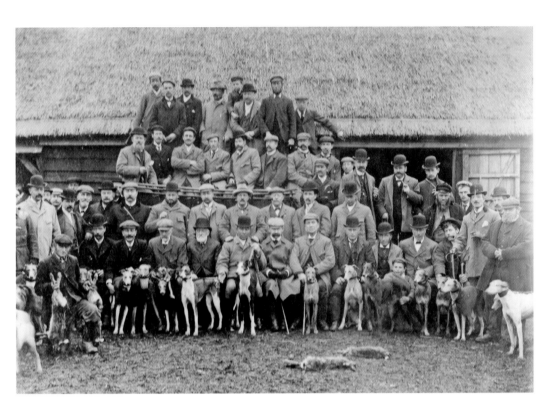

Field Sports
Hare coursing participants at Iwade near Sittingbourne around the turn of the nineteenth century. Below, a group of local men during a break from shooting in woods near Doddington some thirty years ago.

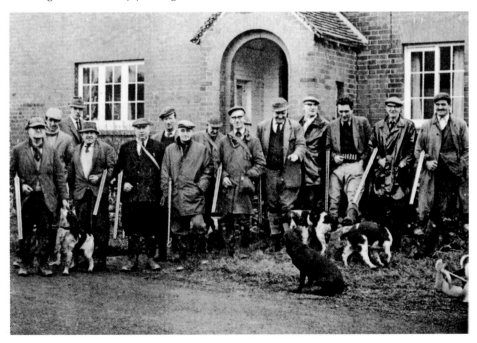

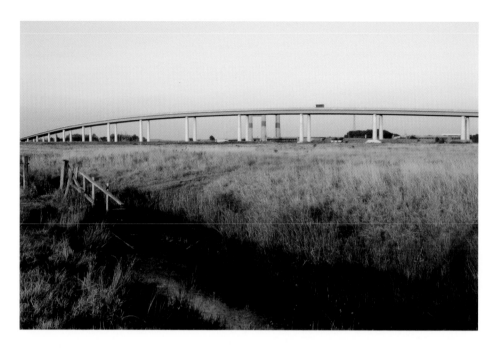

Kingsferry Bridge

Kingsferry Bridge spans the Swale and links the Isle of Sheppey to the mainland and its nearest town, Sittingbourne. This new fixed link is the third structure to ford this waterway. Originally, as the name implies, a ferry boat service provided transportation. The Isle of Sheppey has many royal links with Edward III's wife's castle at Queenborough and Shurland Hall, a popular destination for Henry VIII. As a result of freighters delivering logs to Ridham Dock and regularly colliding with the first old rackety, narrow, lifting bridge, a pillar bridge was provided by the railway company in around 1960. Now popular for water sports, a public house used to stand nearby and was patronised by day-trippers in the early years of motoring.

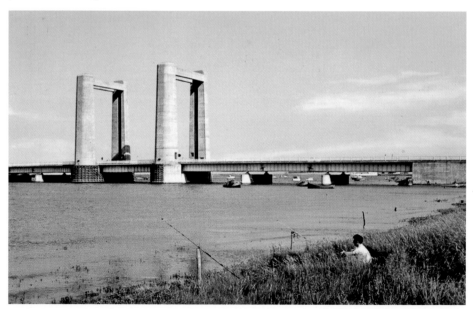

Architectural Gems

Like a priceless piece of modern art, Morrisons' colossal distribution centre has just adorned marshland bordering the Swale. Aimed at blending into the horizon with banded colour-shading, the designers have in fact avoided the anodyne. Architectural prowess from another Elizabethan age is exemplified in this detail below of a Milton doorway.

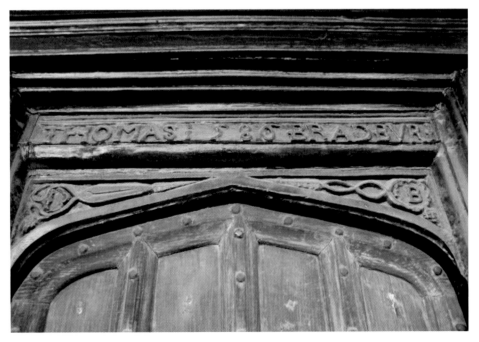

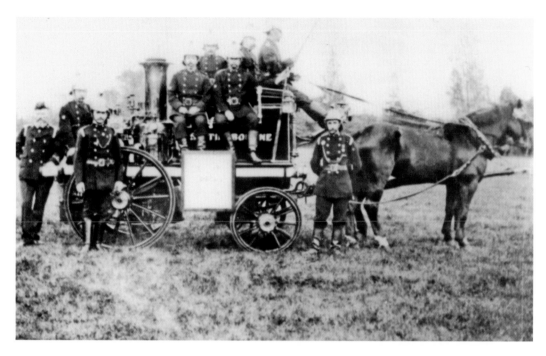

Fire Fighters

Headly Peters' champion fire-fighters and their horse-drawn pump in around 1900. This gentleman was a well-respected businessman whose activities included selling travel tickets to potential emigrants. By contrast Sittingbourne's newest fire appliance is shown out and about on duty.

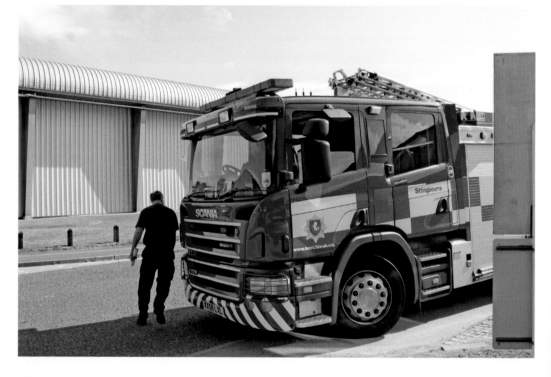

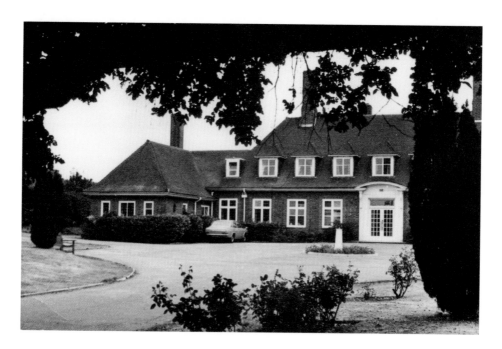

The Memorial Hospital

The Memorial Hospital was gifted to the town by local paper maker Frank Lloyd. Ludicrously threatened with closure during the early 1980s, the political fallout was so potentially enormous that it had the reverse effect. It has expanded into an even greater asset for Sittingbourne. This well-run site comprises a doctor's surgery, pharmacy, a minor injuries unit, and nursing accommodation. It is also the venue for clinics run by peripatetic, specialist medical consultants. Inset is benefactor Frank Lloyd.

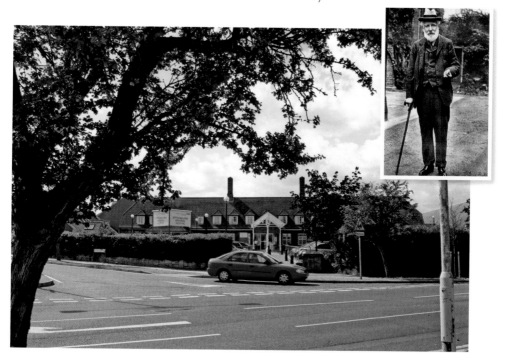

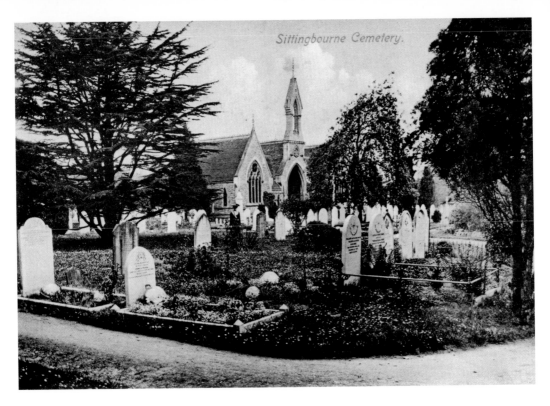

Sittingbourne Cemetery

The cemetery in Sittingbourne was necessitated by a population explosion in Victorian times and lack of space in the graveyard of St Michael's church. The establishment costs were some £2,000, including land purchase and the erection of a chapel and mortuary. Well maintained by Swale Borough Council, this open space has changed little through time.

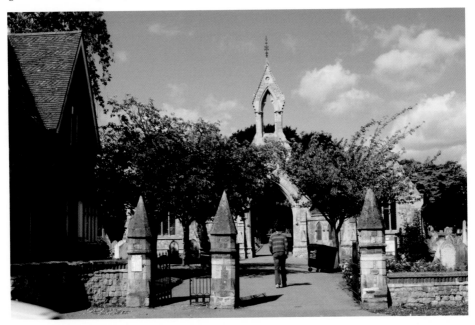

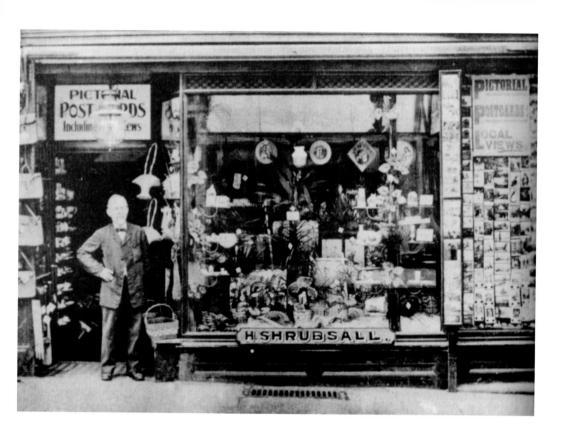

Shrubsall the Stationer

Shrubsall Stationers and Photographers in Sittingbourne High Street was one of an illustrious group that included Ramell, Bennet and Ash. These men deserve particular tribute in this book. Like the clerk in Chaucer's *Canterbury Tales*, they warrant special recognition. It is their efforts which ensured a record for future evaluation. On the right is an image from a typical postcard sold in Mr Shrubsall's shop. Soldiers camped or billeted in the town prior to embarkation to the battlefields of France, often sent them to their loved ones. Following post office deregulation they became the e-mails of their time.

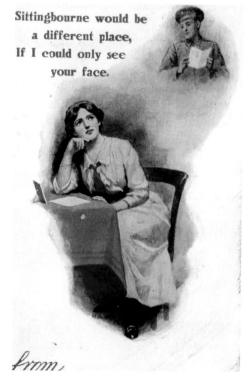

Sittingbourne would be a different place, If I could only see your face.

from

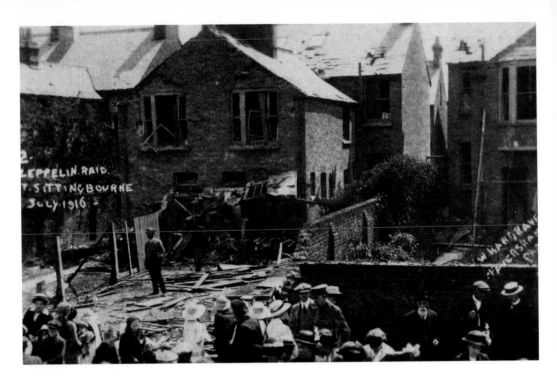

Bombs on Sittingbourne

Sittingbourne's close proximity to German airbases made it vulnerable to wartime air attack. The picture above indicates damage from Zeppelin bombs in Unity Street off Park Road. To promote propaganda and restrict panic the postcard below was issued, ridiculing dangerous air raids.

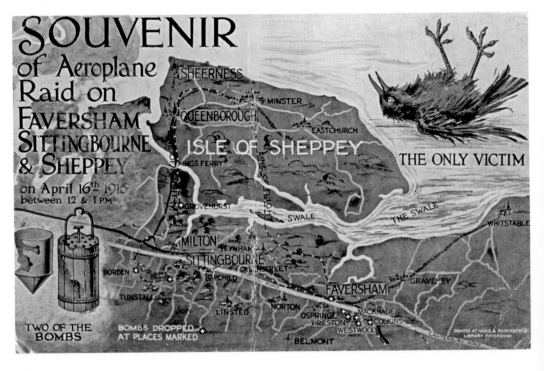

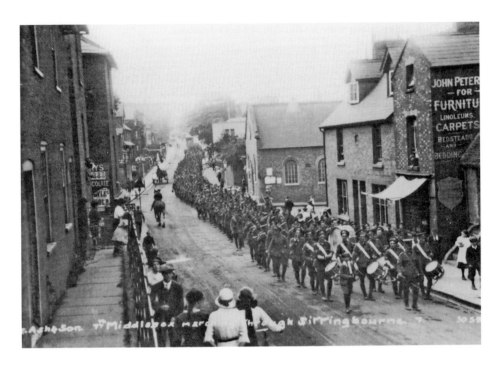

The Great War

Marching off to end the war of all wars, soldiers snake down Holly Bank Hill into West Street. The surrounding countryside was dotted with temporary military camps. Gore Court for example was covered with a forest of army tents. Those men who survived were rewarded with medals such as these below.

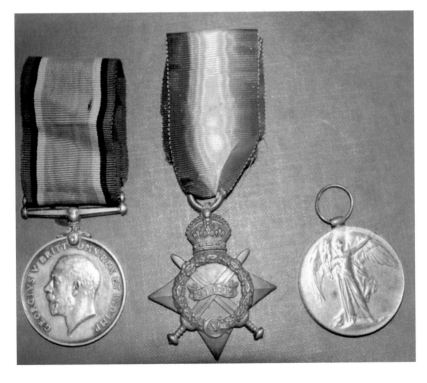

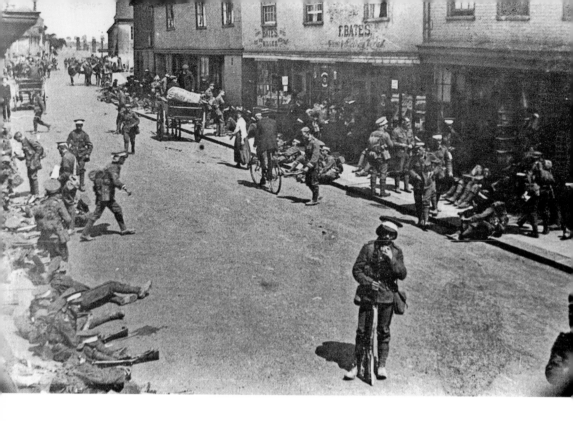

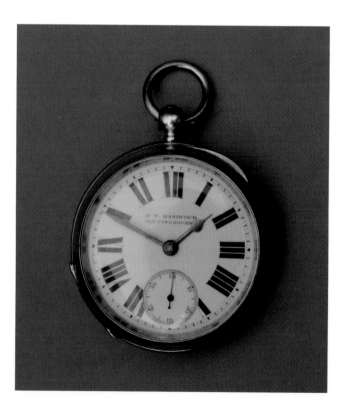

War Memento

This watch travelled out to Palestine in the pocket of a British soldier. For whatever reason, it remained there for some ninety years before it was acquired from a dealer in Jerusalem and returned to its home town. Sittingbourne had at least three watchmakers. Forsters was a Regency retailer while Hancock's in the High Street survived into living memory. Maybe one of the very soldiers pictured above resting between exercises in the Milton area could have owned an identical timepiece.

Homeguards

Dad's Army in a formal group shot. This contingent was from Rodmersham. They were a disparate bunch including a gentleman of independent means, men with reserved occupations such as farming, and even a hardened soldier who had served with the Black and Tans in Ireland. The Drill Hall, Crown Quay, where they trained, is now used for homeless people. It is called The Quays and is run by church authorities.

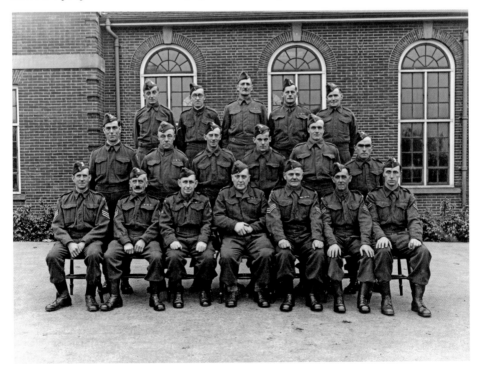

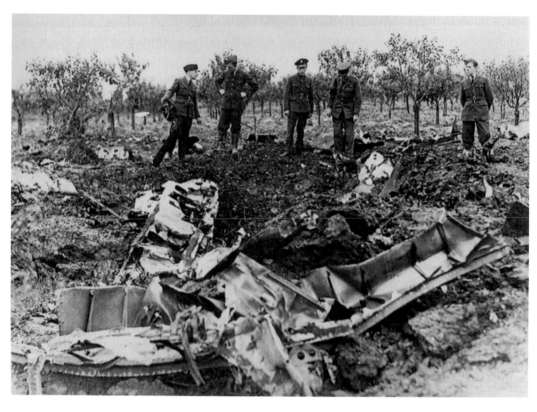

Memories of the Second World War
Here are two classic scenes of the Second World War period in Swale. First of all, a crashed German plane at Bicknor. Secondly, Land Army girls helping to boost food production.

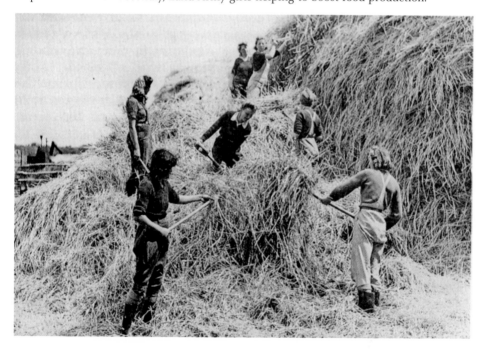

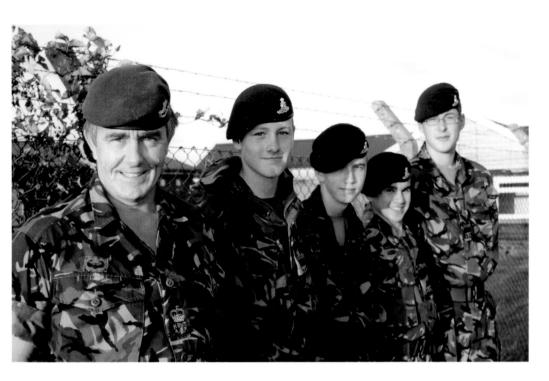

Cadet Forces

Vitalising young lives at Sittingbourne Sea Cadets are chairman Peter MacDonald, Commanding Officer Loreley Tansley, PO Laura Patient and PO David Friday. They are the epitome of good volunteers. Moreover, their dedication is proof of powerful forces for cohesion in Sittingbourne's community. The well-ordered hut housing their headquarters is placed within feet of a water-filled moat which once protected King Alfred the Great's Bayford Castle. Potential soldiers of the future are near-neighbours to the sea cadets. They are seen above under the expert supervision of Sgt Major Instructor Kevin Parker (Detachment Commander).

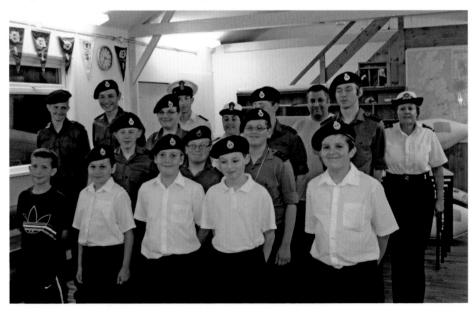

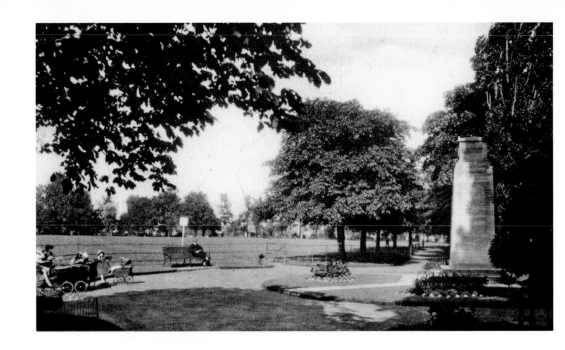

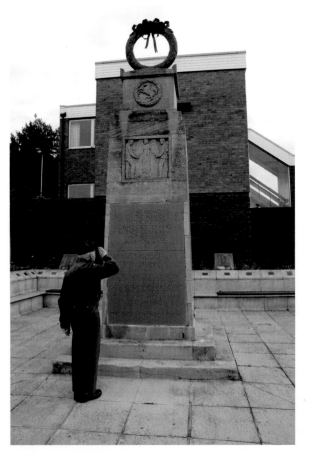

War Memorial

The recreation field off Albany Road was purchased for the town in late Victorian times to provide an amenity for the populace from homes springing up on the southern, more desirable, side of town. The war memorial seen on the left has been re-sited in Central Avenue. Seen here saluting his fallen comrades is local stalwart and old soldier Keith Chisman.

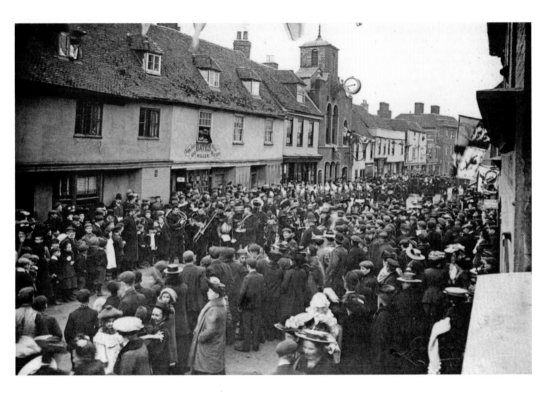

Boer War Commemoration, Milton

Milton Regis High Street was the scene of this assembly in 1906 to commemorate the memory of two local soldiers killed in the Boer War. Now a conservation area with many listed buildings, its overall appearance has changed little over the past century.

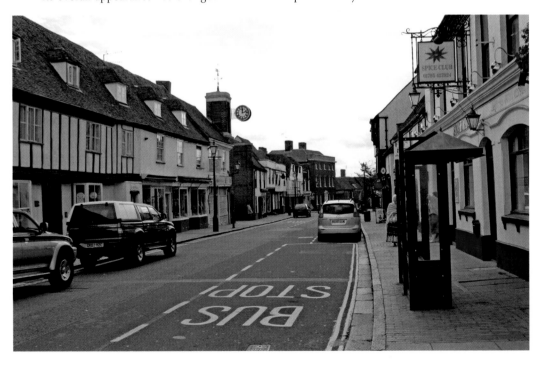

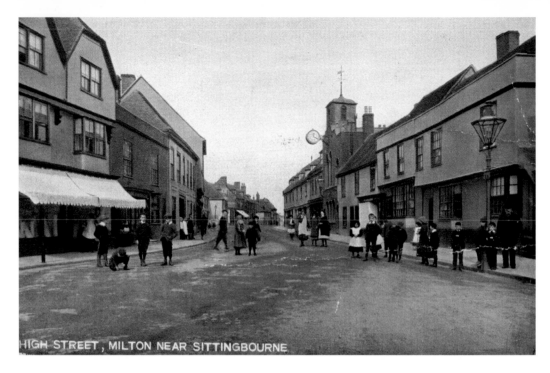

HIGH STREET, MILTON NEAR SITTINGBOURNE

Milton High Street

Milton's main thoroughfare is virtually unaltered over the past century. Edwardian children posing for posterity can be seen in front of Bradbury House. An historic building of Kent, this was the Elizabethan home of a wool merchant. Within its many rooms there is a bread oven, and niches for the winter storage of beehives in the cellar. There is also a trap door near the front door for provisions to be dropped into the basement. The Reverend Lough established a grammar school here in the late eighteenth century. Boarders' initials can still be seen carved in the attic rooms.

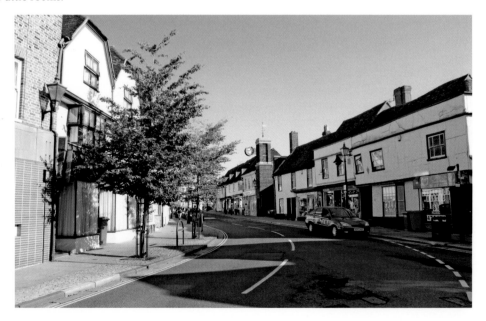

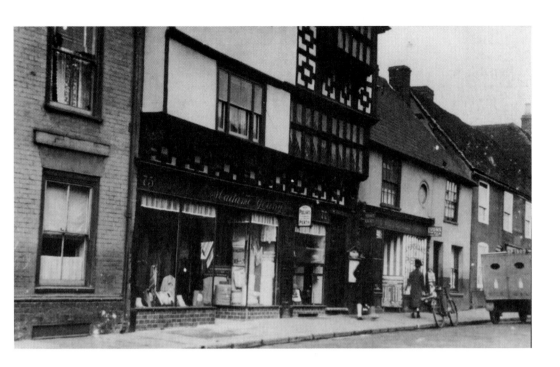

Milton Post Office

The post office in Milton High Street has been sensitively restored and maintained. This distinctive building from the seventeenth century is rumoured to have been involved in the silk business. Hence its tallness designed for drying long lengths of fabric. Although the beautifully carved beam bosses on the lower floor are contemporaneous with the building's age, the higher beams and carvings were added only around 100 years ago, albeit they are salvaged originals. When postal business from Milton was operated in another premises near Bradbury House, Madame Young purveyed corsets and other female requisites from her atelier.

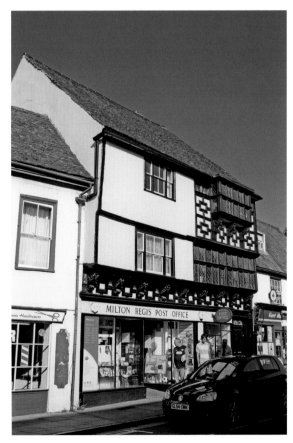

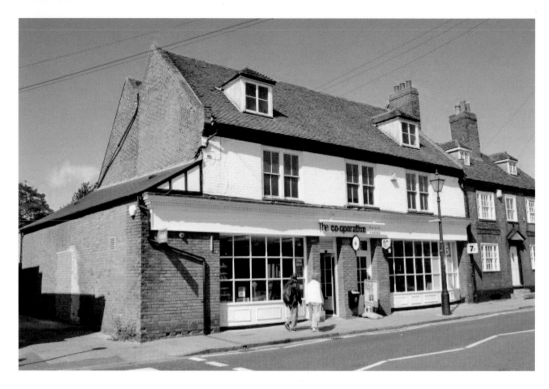

Milton Co-Op

Milton Co-operative Society shop, following a recent makeover. It is a main hub of the High Street with a roaring trade in lottery tickets. Unlike the Victorian outlet below, cash is dispensed from an automatic teller machine. The advertisement for Sunlight soap reminds us that this product is still available.

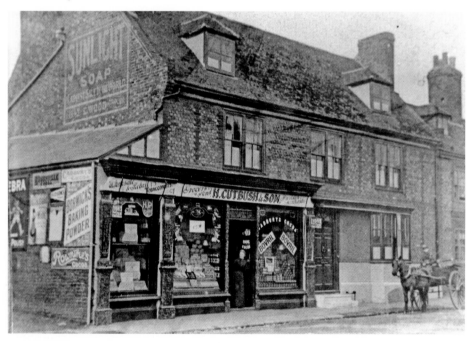

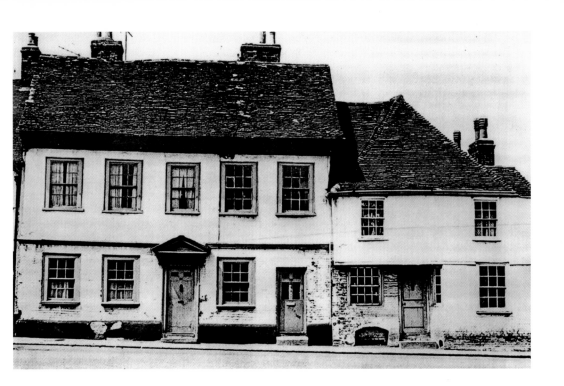

Milton High Street, North End
This area of Milton Regis High Street was where blacksmiths and wheelwrights plied their trade. The derelict building has gone and has been replaced by a car park for customers of the Charcoal Grill.

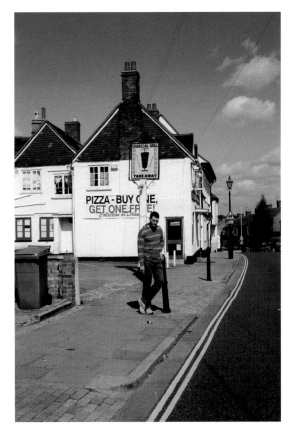

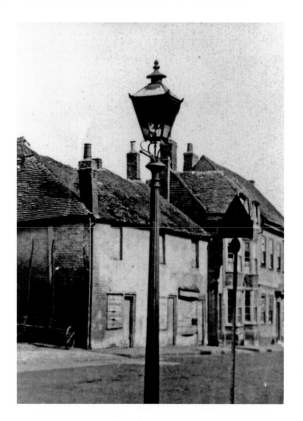

Surgeon's House, Milton

Further down the road was the early eighteenth-century residence of a surgeon. As can be seen from the before and after photographs, it has in the past been subdivided into two homes but has reverted to a single dwelling. On an ancient site, this listed building has behind its Georgian façade a timber frame of a medieval hall house. An old oak mullioned window frame survives with its original lead rings to hold lattice glass. Underneath there is a four-chamber cellar, part of which was a Norman undercroft.

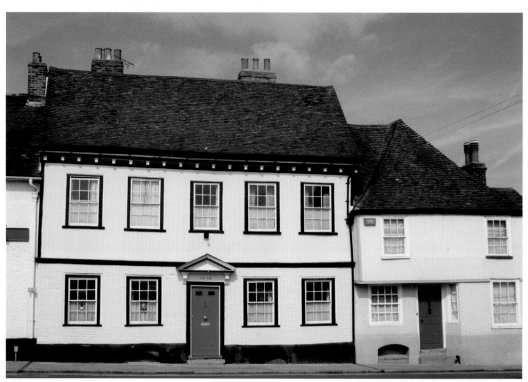

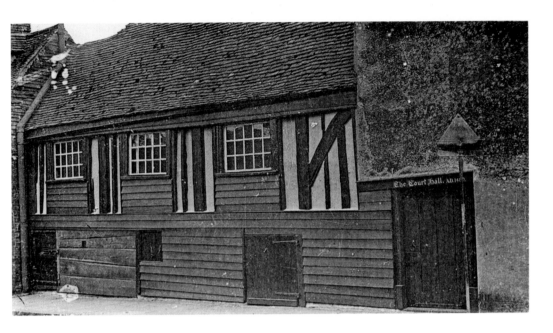

Court Hall, Milton Regis

Milton Court Hall was built in the late fifteenth century. By the 1950s it was a somewhat dilapidated store in danger of demolition. Mercifully saved by a local benefactor, it was restored under the supervision of Major Clarke of Newington Manor. This architectural treasure is fitted with an original judge's bench in the upstairs chamber. Below the courtroom are the town's lock-up jails. The grills in the doors of these cells can still be seen in the picture below.

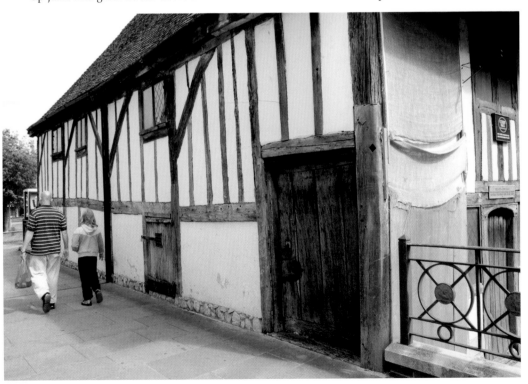

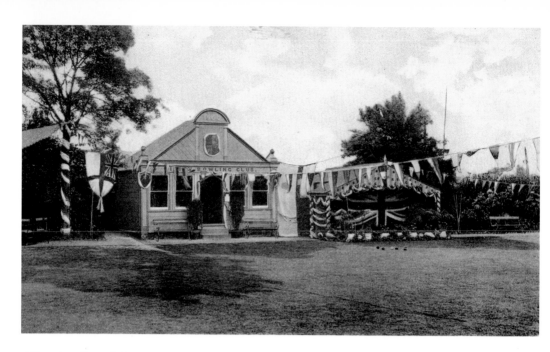

Milton Bowling Club

Milton Bowling Club is the second oldest in England, being established in 1540. The green itself may actually be the oldest in continuous use. Local legend has it that Sir Francis Drake's father, who was vicar of a nearby parish, may have played here. Today the clubhouse has been replaced with excellent up-to-date facilities. The present players are representatives in England teams. Wendy King, for example, won the Women's National Two-Wood Championship in 2009.

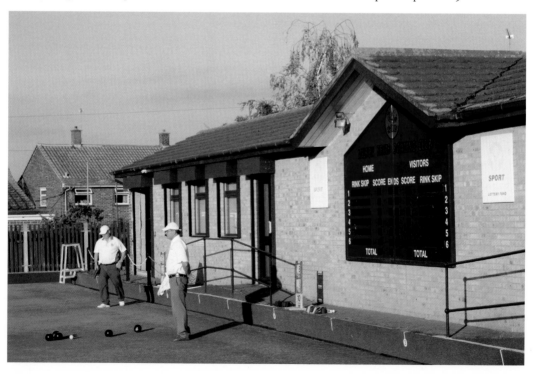

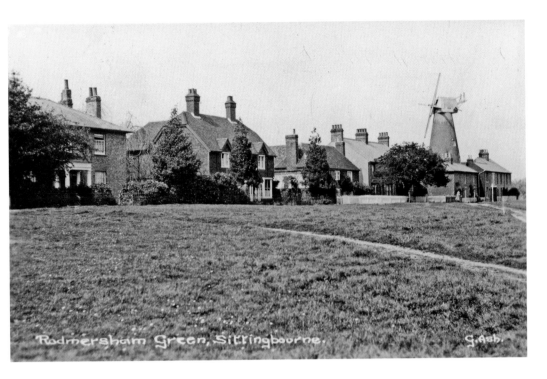

Rodmersham Green

Rodmersham Green is a picturesque settlement just south of Sittingbourne. Now a Conservation Area it retains its tranquil beauty. However, it sadly mourns the loss of its emblematic windmill. Its wanton destruction for modern housing redevelopment was probably the last example of this kind before local authorities became more aware of heritage concerns.

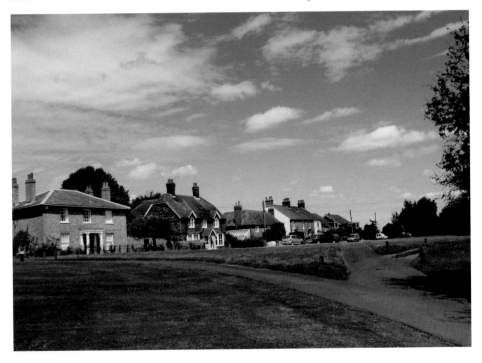

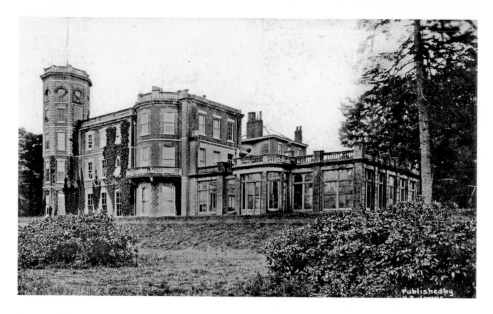

Torry Hill

Torry Hill estate at Frinsted near Sittingbourne was put together in Victorian times by the Leigh-Pemberton family. Much of the acreage is covered by sweet-chestnut coppices, which provide the raw material for traditional spile fencing. The current incumbent, the Rt Hon. Lord Kingsdown KG PC, was governor of the Bank of England during the Thatcher years of government administration. Well able to furnish his Lordship's joy of country pursuits, the property is exceptional in boasting not only its own small-scale steam railway (complete with viaduct — made from miniature bricks — and tunnels through woodland) it also has its own cricket pitch and fives court. A delightful, immaculate garden has been created in a redundant walled tree nursery. During the 1950s the replacement house (below), of more manageable proportions, was erected.

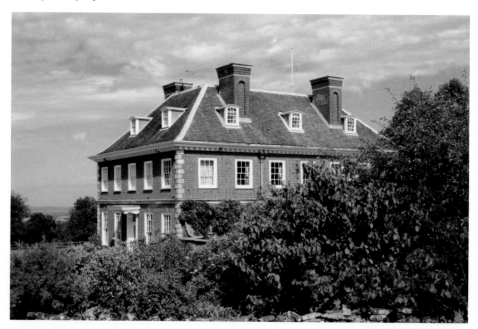

Gardening

The popularity of gardening is undiminished over the past century. Below is a snap from one of the many local horticultural shows in and around Sittingbourne. The gentlemen in the old photograph were entrants of Kent's Best Vegetable Grower competition. On this occasion a proud grower from Milton Regis is seen wearing the winning sash of honour.

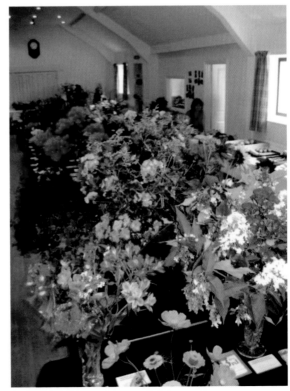

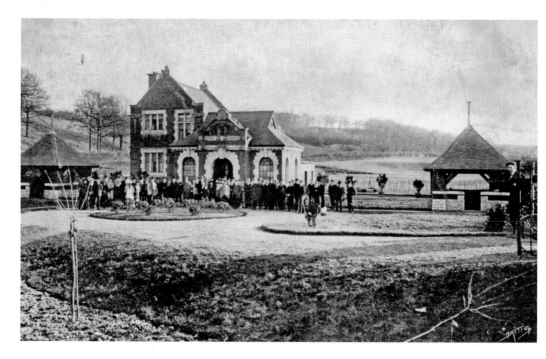

Highsted Waterworks

Sittingbourne benefited from a piped water supply when waterworks were established at Keycol Hill in 1870. For some years the adjacent community of Milton Regis shared this supply but by the end of the century they decided to go their own way with a separate new pump station at Highsted Valley. Eventually the two municipalities amalgamated resources in 1930 with the unification of the councils. The home for a resident engineer was sold off following privatisation of utilities in the 1980s. For a while it became an infants' day nursery, but after many additions and modifications it retains its circular garden bed on the entrance drive.

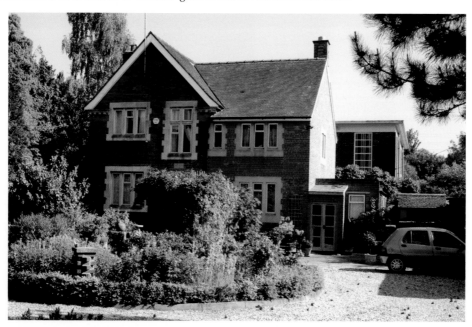

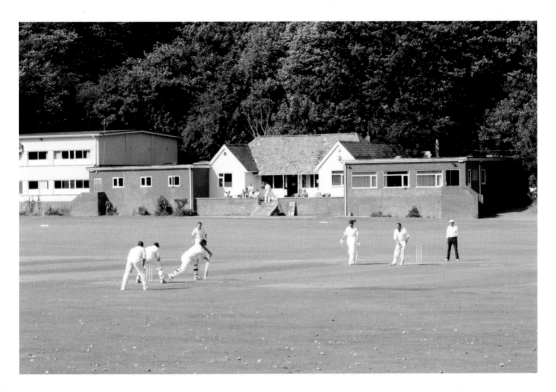

Cricket at the Grove

Cricket of a high standard has been played at The Grove, Sittingbourne, for many generations. The scenic grounds were formally part of the hereditament of a house on the hill above. This early snapshot below shows the first pavilion which is now surrounded by further changing rooms and squash courts.

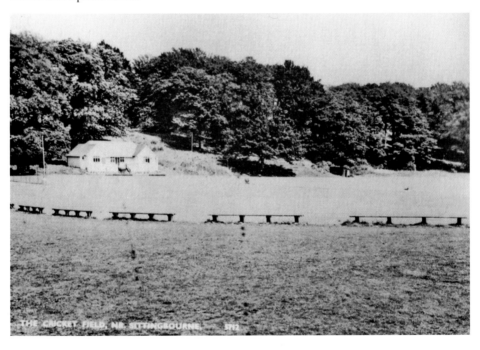

THE CRICKET FIELD, NR. SITTINGBOURNE.

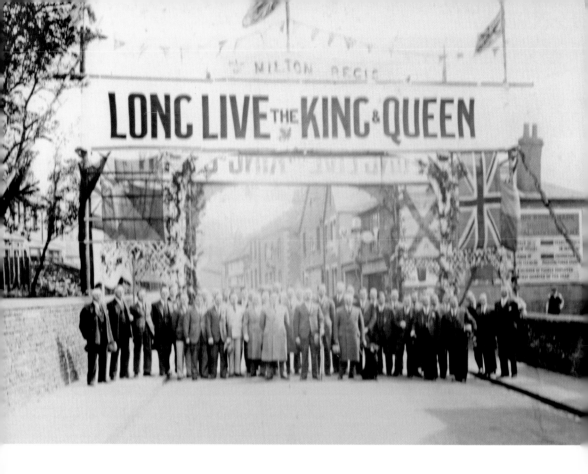

Acknowledgements

Thanks go to Beverly Smith, John Crunden, Bryan Clarke, Mrs Doreen Williams, Keith Chisham, Bill Baum, Tony Rickson, Lena Jordan, and a special debt of gratitude is owed to Christiaan de Lange, whose invaluable assistance was greatly appreciated.